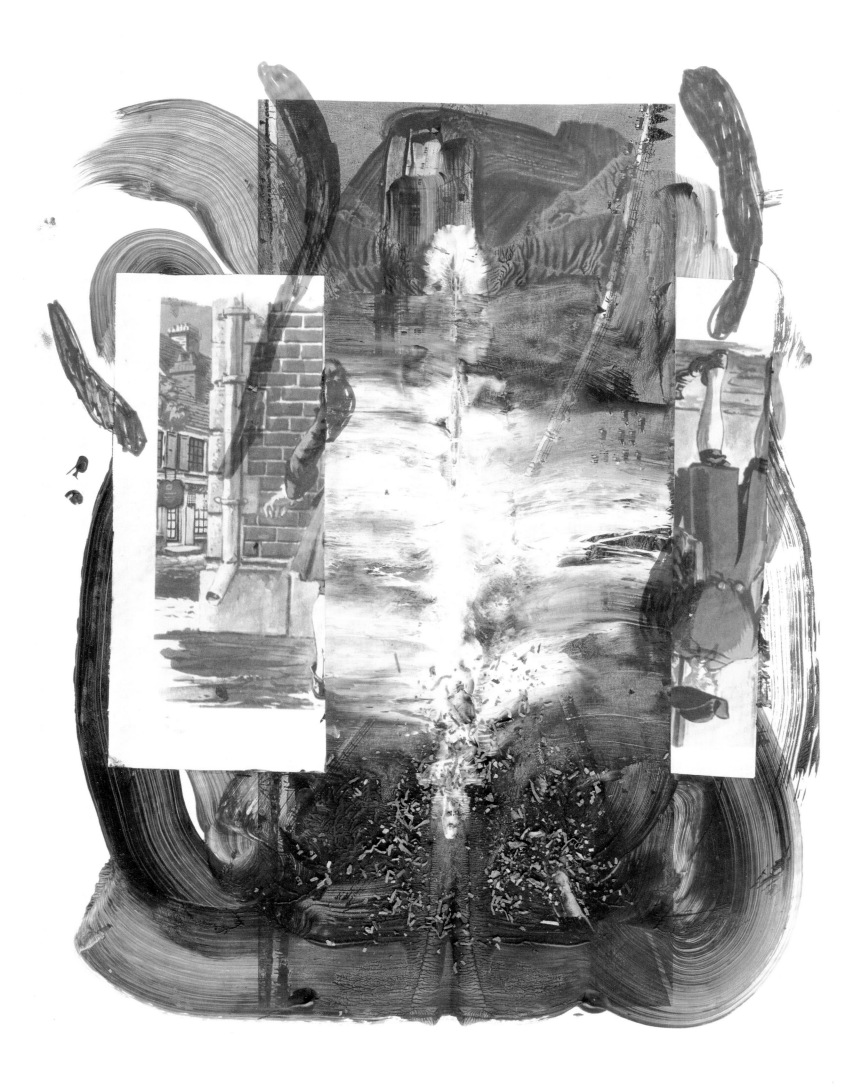

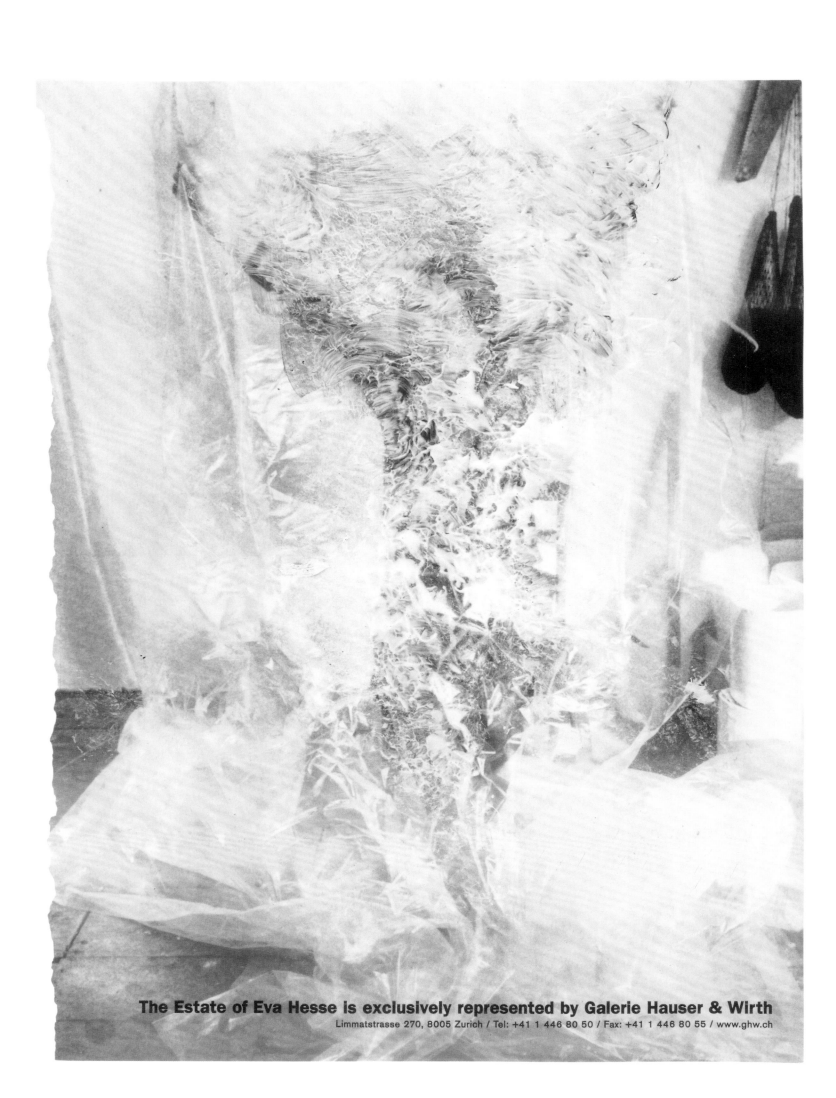

The Estate of Eva Hesse is exclusively represented by Galerie Hauser & Wirth
Limmatstrasse 270, 8005 Zurich / Tel: +41 1 446 80 50 / Fax: +41 1 446 80 55 / www.ghw.ch

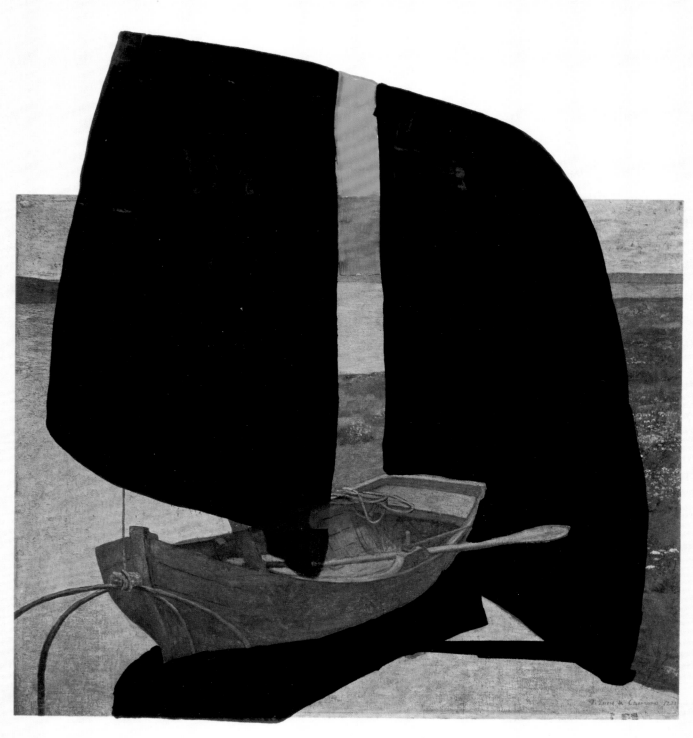

Tafel 4 Pierre Puvis de Chavannes, *Der arme Fischer*, 1881, Louvre, Paris

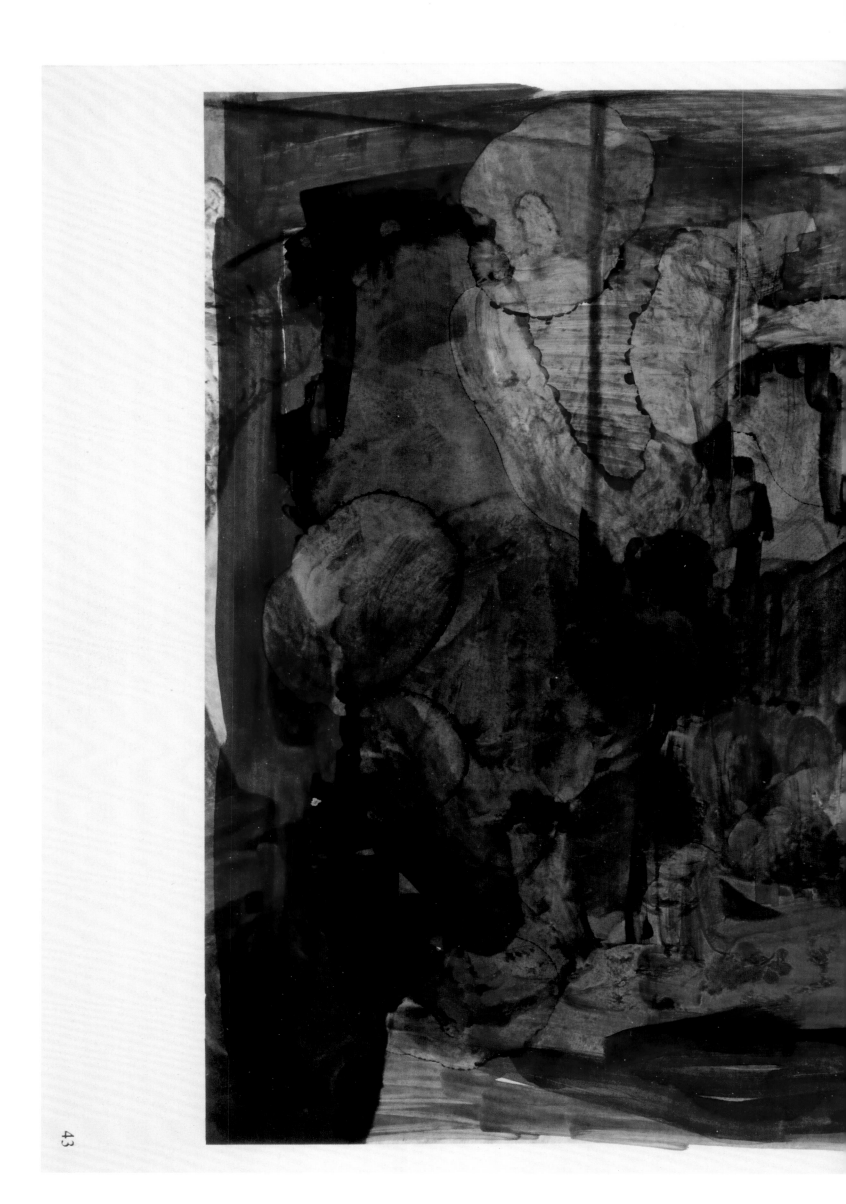

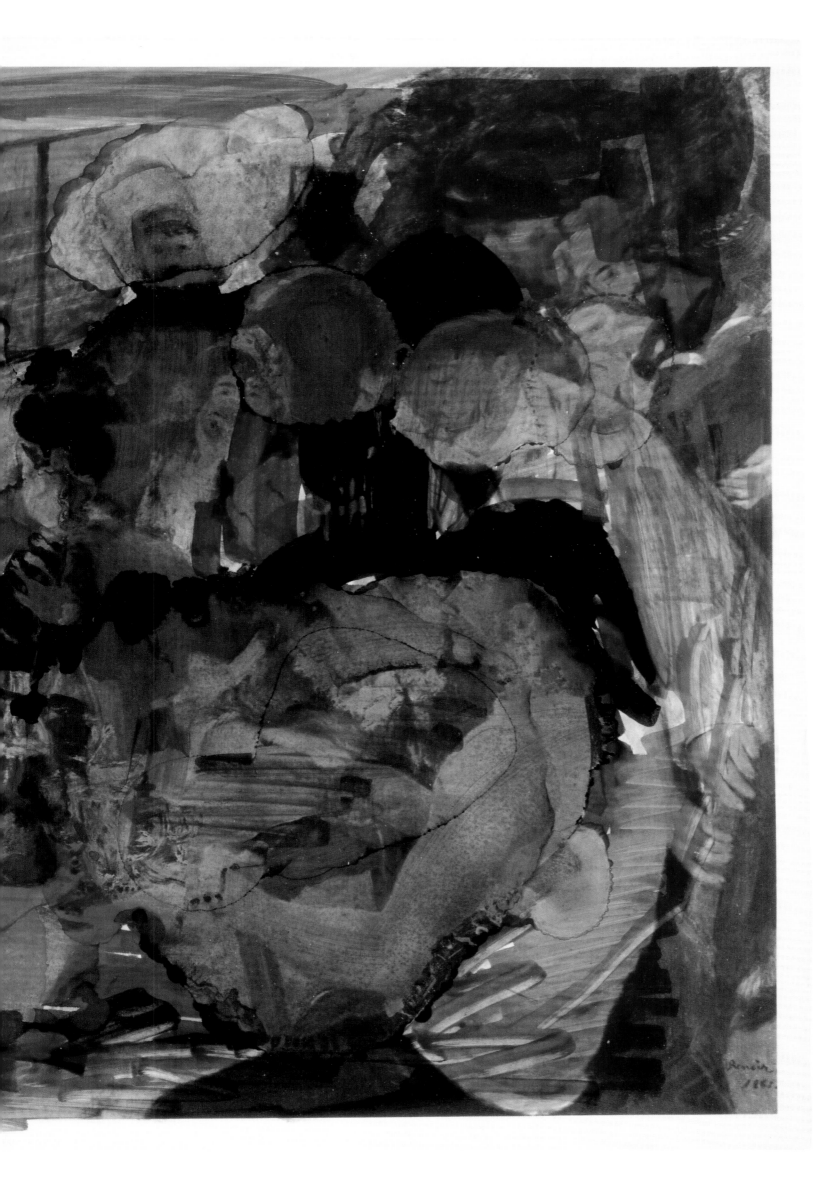

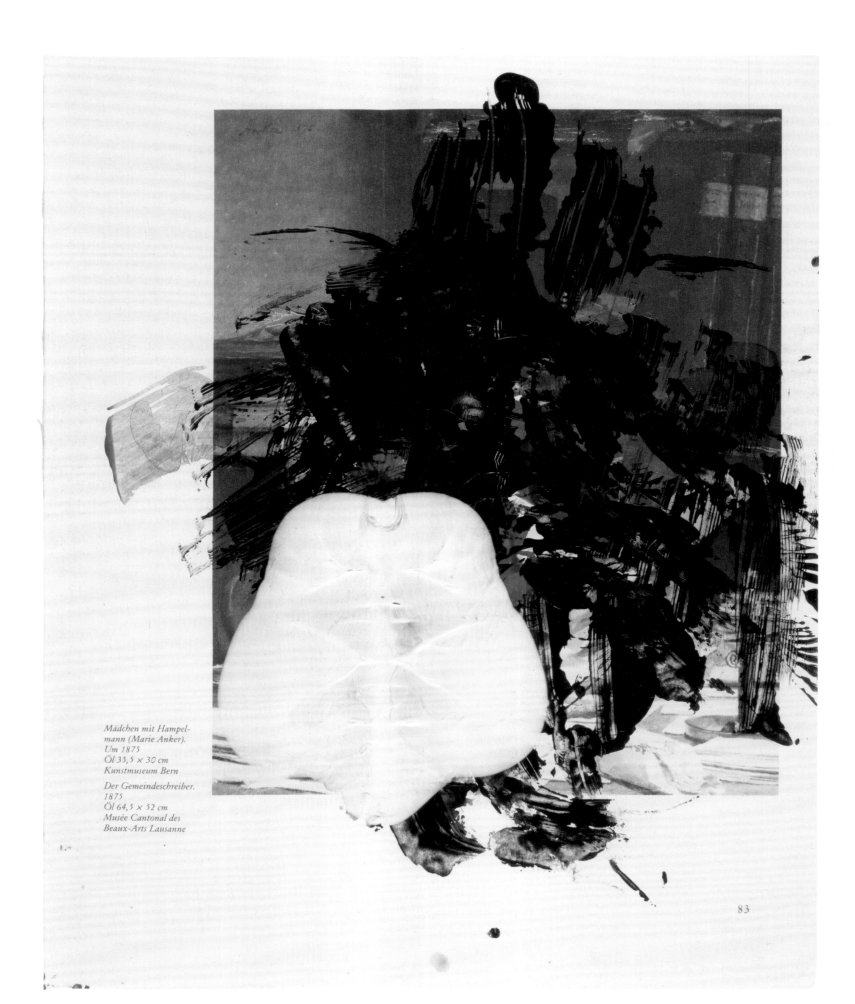

*Mädchen mit Hampel-
mann (Marie Anker).
Um 1875
Öl 35,5 × 30 cm
Kunstmuseum Bern*

*Der Gemeindeschreiber.
1875
Öl 64,5 × 52 cm
Musée Cantonal des
Beaux-Arts Lausanne*

CHEFS-D'ŒUVRE DE L'ART
GRANDS PEINTRES

HACHETTE

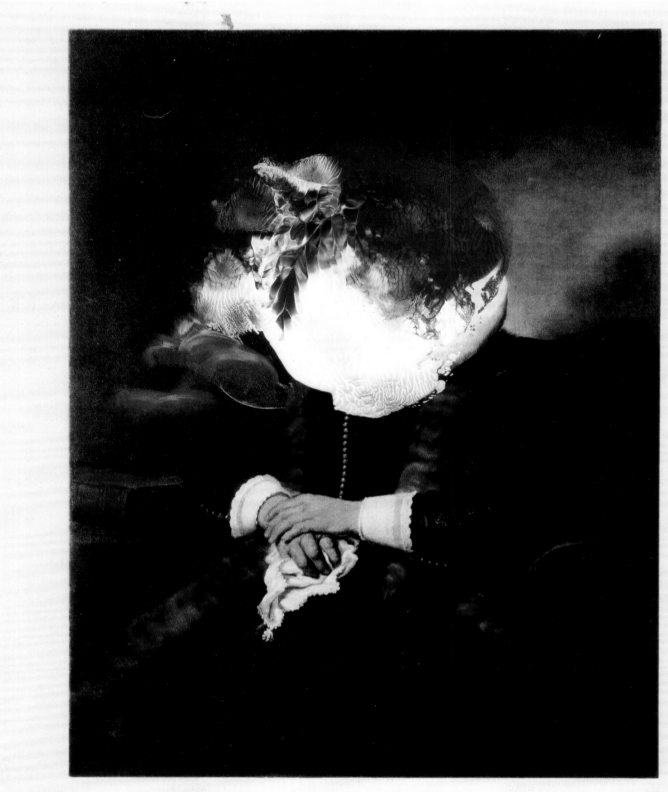

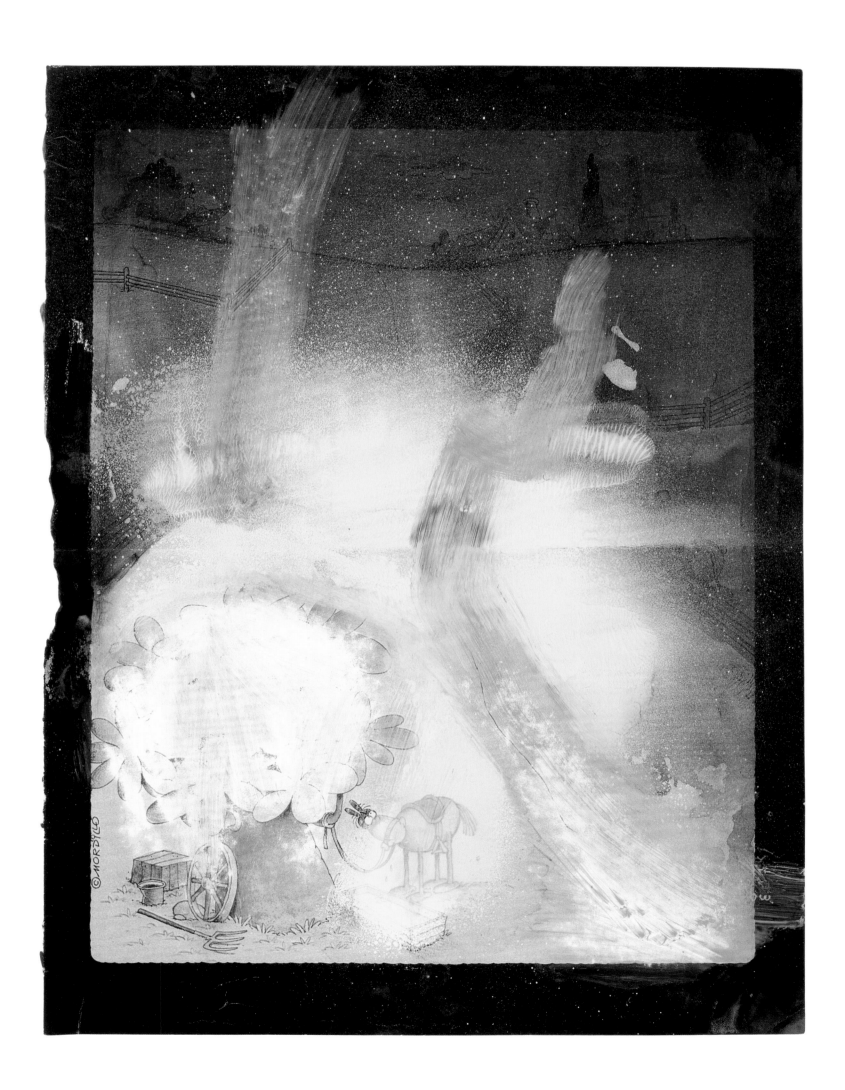

David Renggli

Cage Writes Bird.

Selected works 2002–2007

Edited by Dorothea Strauss & Christoph Doswald
Codax Publisher 2007

Table of Contents

1000 und eine Bilder Nr. 366 .. 1
1000 und eine Bilder Nr. 381 .. 2
1000 und eine Bilder Nr. 89 .. 3
1000 und eine Bilder Nr. 932 .. 4
1000 und eine Bilder Nr. 181 .. 5
1000 und eine Bilder Nr. 733 .. 6
1000 und eine Bilder Nr. 429 .. 8
1000 und eine Bilder Nr. 189 .. 9
1000 und eine Bilder Nr. 227 .. 10
1000 und eine Bilder Nr. 614 .. 11
Holz macht süchtig ... 17
Truhe mit Spalt .. 18
Interview with a Wall .. 19
Die, die sich hochgeschlafen ... 20
Studies for Enlightment ... 21
The Night it Suddenly Became Bright Again ... 22
Studies for Enlightment ... 25
Train from A to B (Hangout) .. 26
Flat Tire Make Higher ... 28
Studies for Enlightment ... 30
The Night Sculptures .. 32
Bagger essen Wand auf ... 34
Die, die sich hochgeschlafen ... 35
Holz macht süchtig, Gruppe .. 36
Strippen für Piepen .. 37
For What Would You Believe Something You Don't Believe ... 38
Strippen für Piepen .. 40
Im stehen siehts sich höher .. 41
Train from A to B (Hangout) .. 42
While I Work My Bed Sleeps ... 43
Interview with a Wall .. 44
Studies for Enlightment ... 46
Bagger essen Wand auf ... 47
Des Gabels Gabe ... 48
Strippen für Piepen .. 49
The Night it Suddenly Became Bright Again ... 50
Sometimes I Wish the World was in Slowmotion/Train from A to B 52
Sometimes I Wish the World was in Slowmotion (Studies) ... 54
Portrait Nr. 4 .. 61
Sometimes Sunday is on Tuesday ... 62
You're Always Late ... 64
Helm von hinten .. 65
Perspecktiven .. 66
Einsicht durch Durchschnitt .. 68
Spiegelung ... 70
You're Always Late (Between Open and Closed) .. 72
Im Wasser .. 73
Das Grosse Rasenstück ... 75

Truhe für gestohlene Zeit .. 76
Jalousienlicht das sich an der Ecke bricht 78
Durst kommt vor Singen ... 79
Kranz Unten .. 80
Ab welchem Alter wirken Selbstgespräche eigentlich komisch 81
Hommage an die Interpretation der Zeit 82
Leihgabe ans Nichts ... 84
Compressed Pub ... 87
If I Could Paint, I Would Paint You a House 88
Was befohlen, wird gemacht/Antwort aus der Höhle der Fragen 89
Berg der Beleidigten/Lust und Moral .. 90
Des Tumblers Gabe .. 91
Der Apfel fällt nicht .. 92
While I Work my Bed Sleeps .. 94
Melancholie von Hinten und von Vorne .. 96
Es widerspricht jeglicher mir anerzogenen Logik dass das n auf das m folgt 98
Retouchen ... 100
Der Tag an dem ich das Brot erfand .. 111

Text .. 113

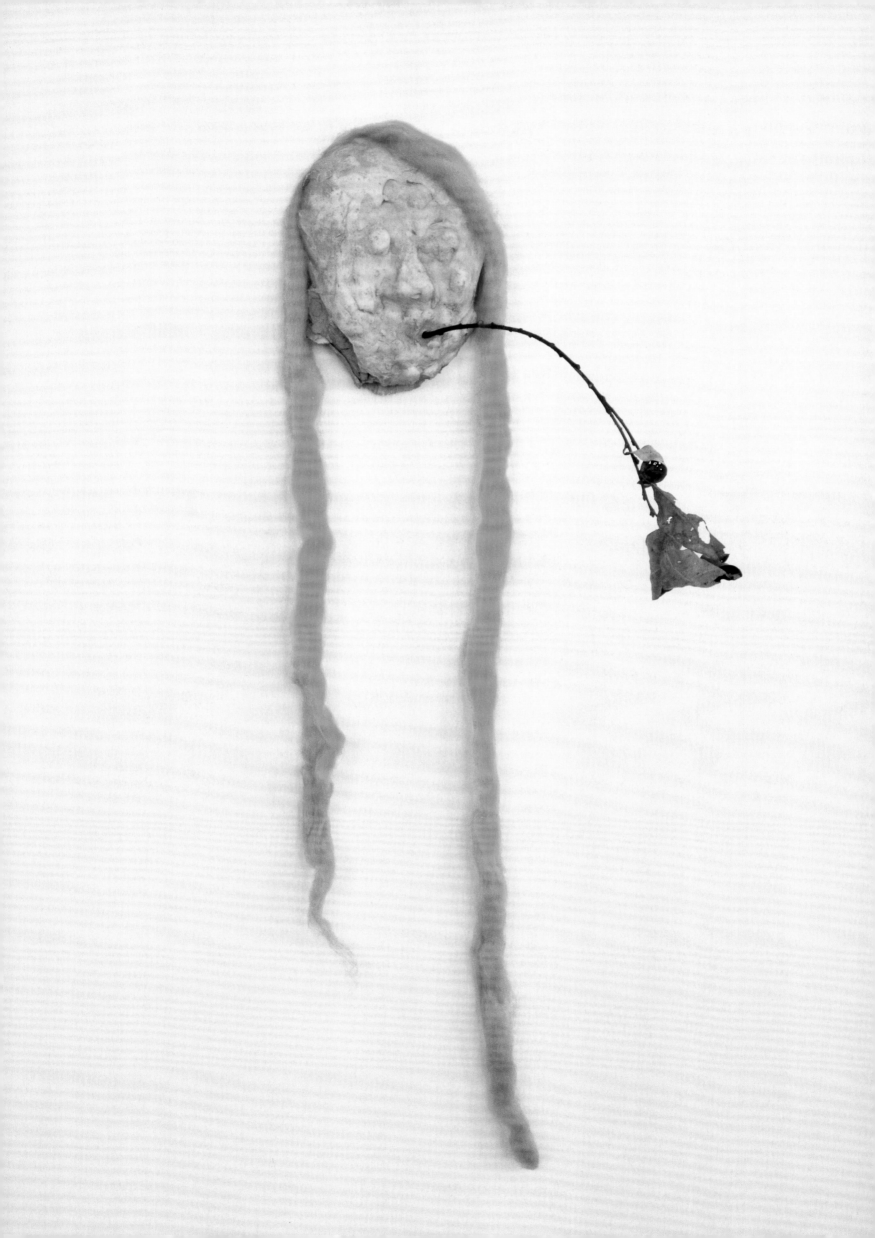

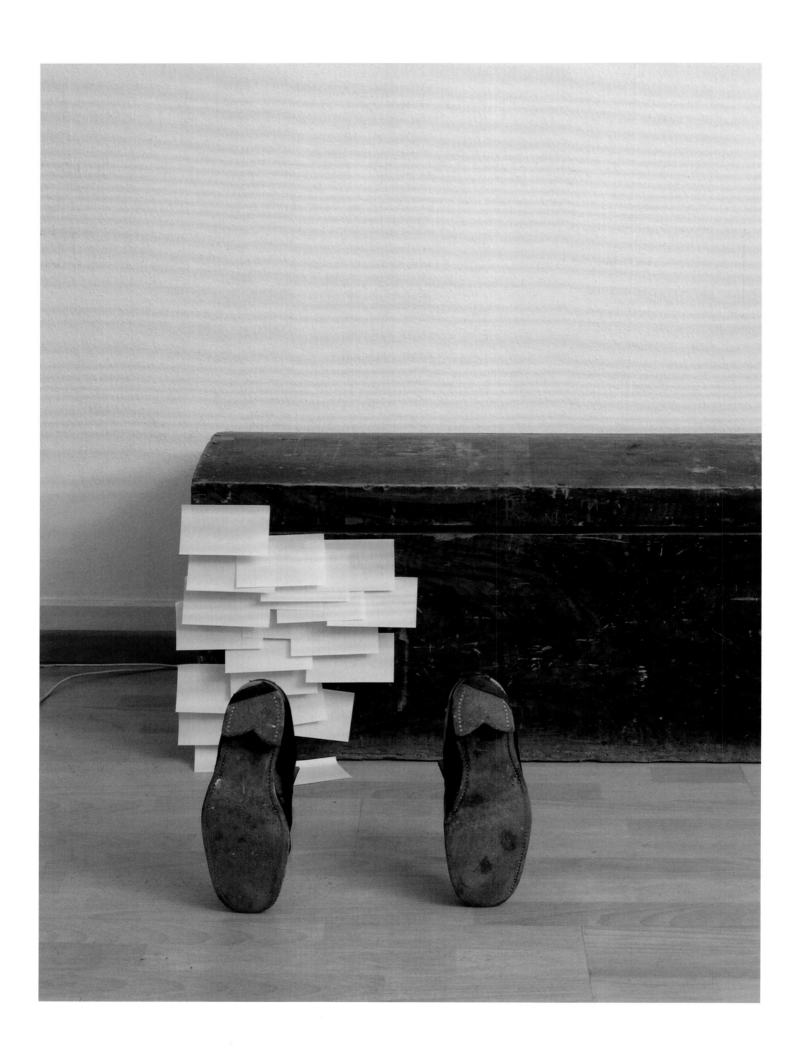

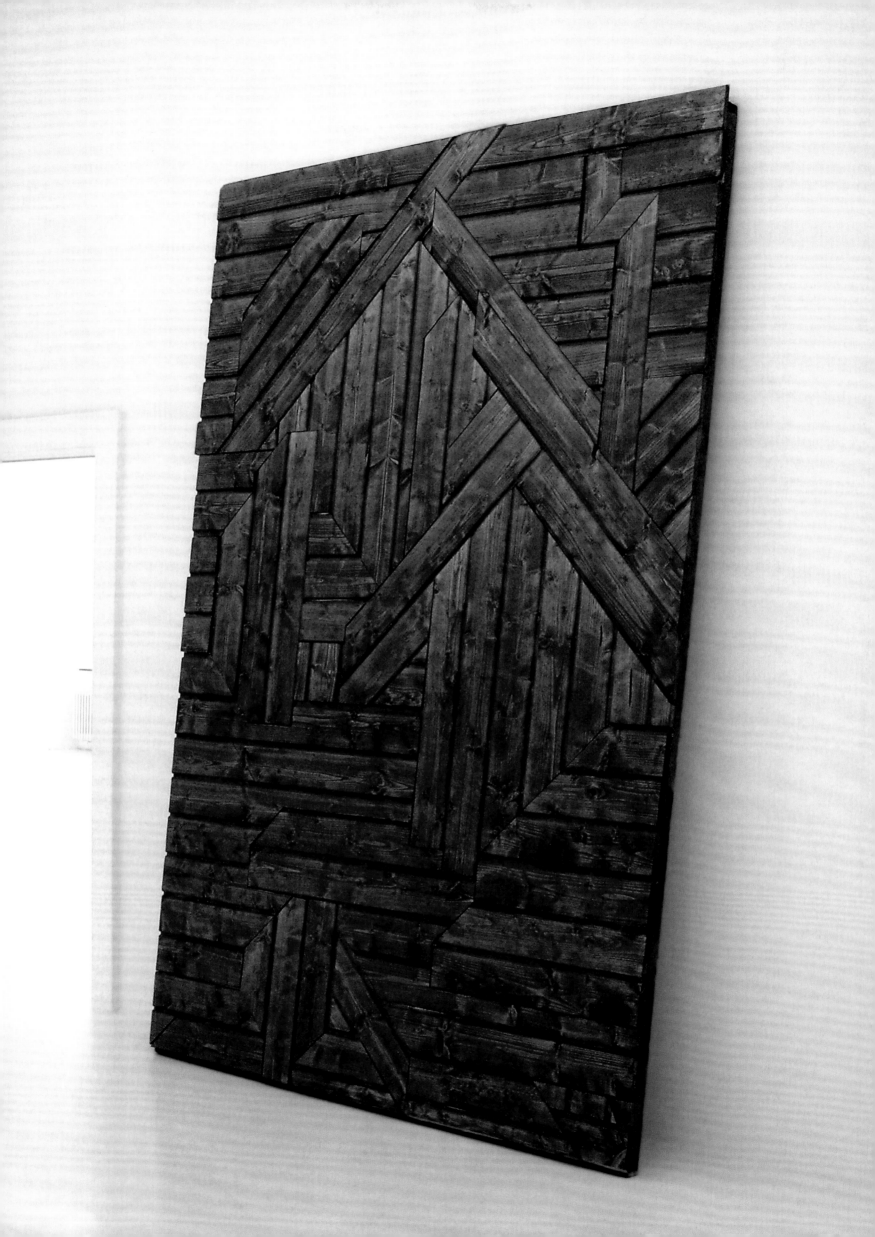

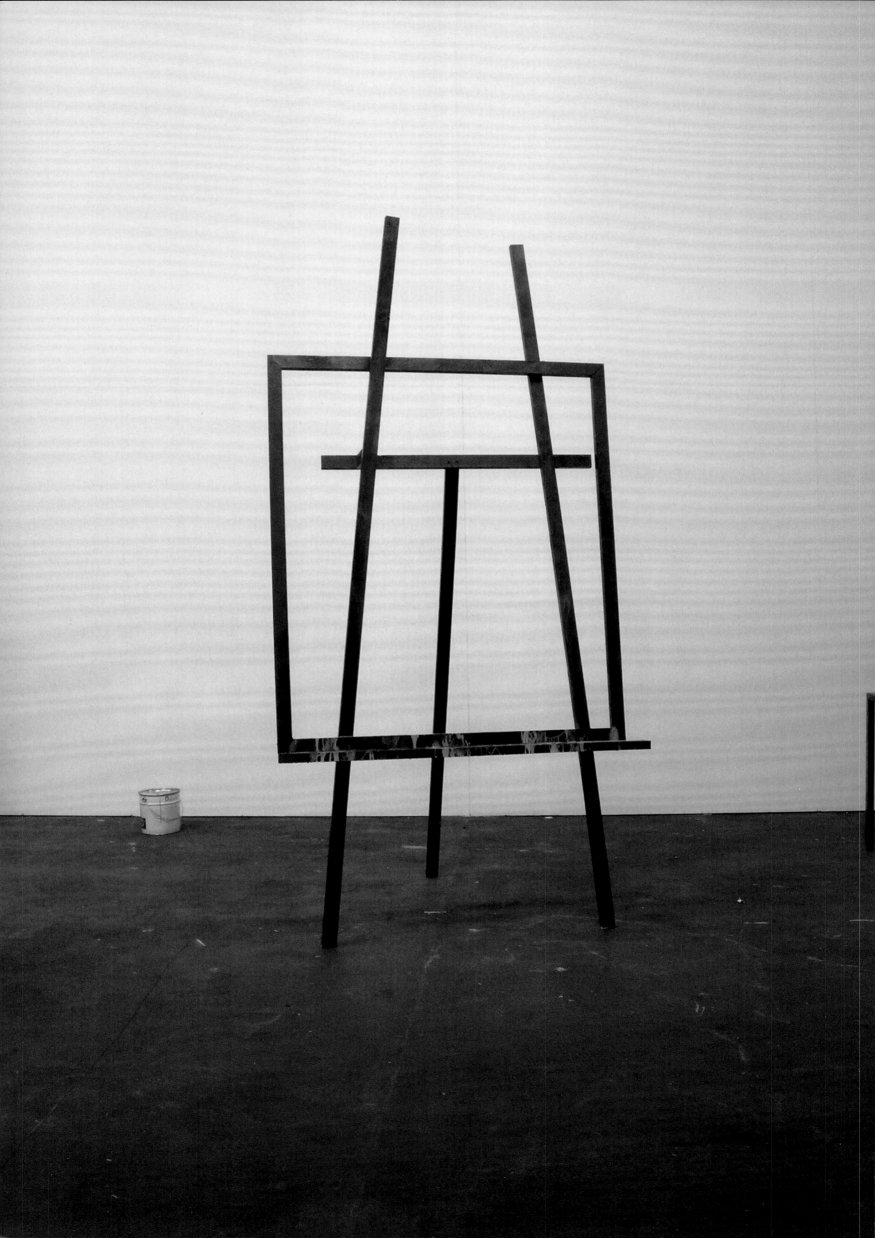

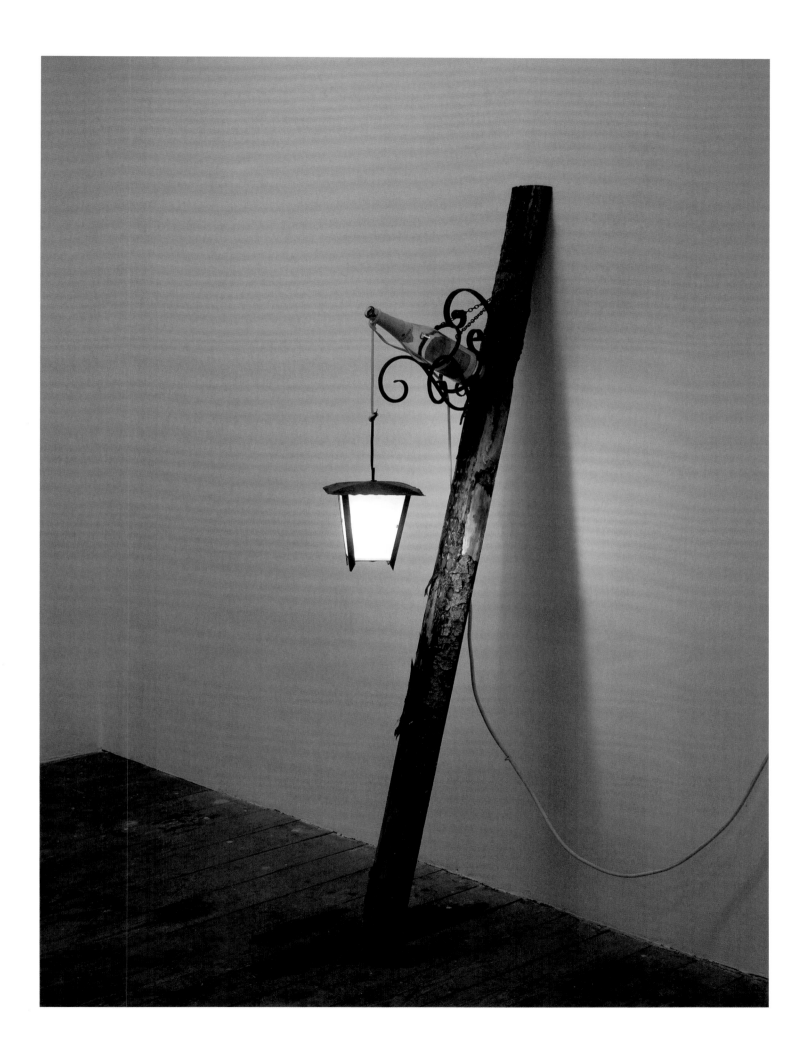

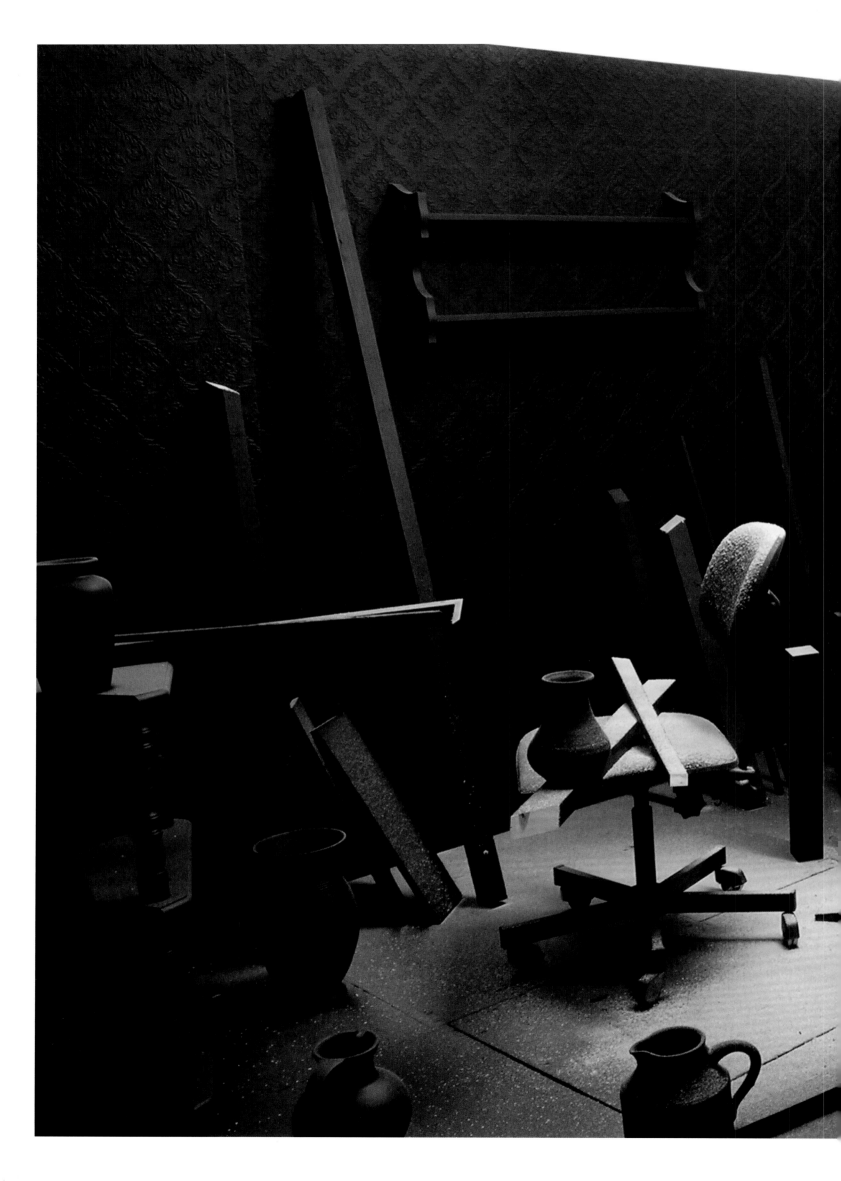

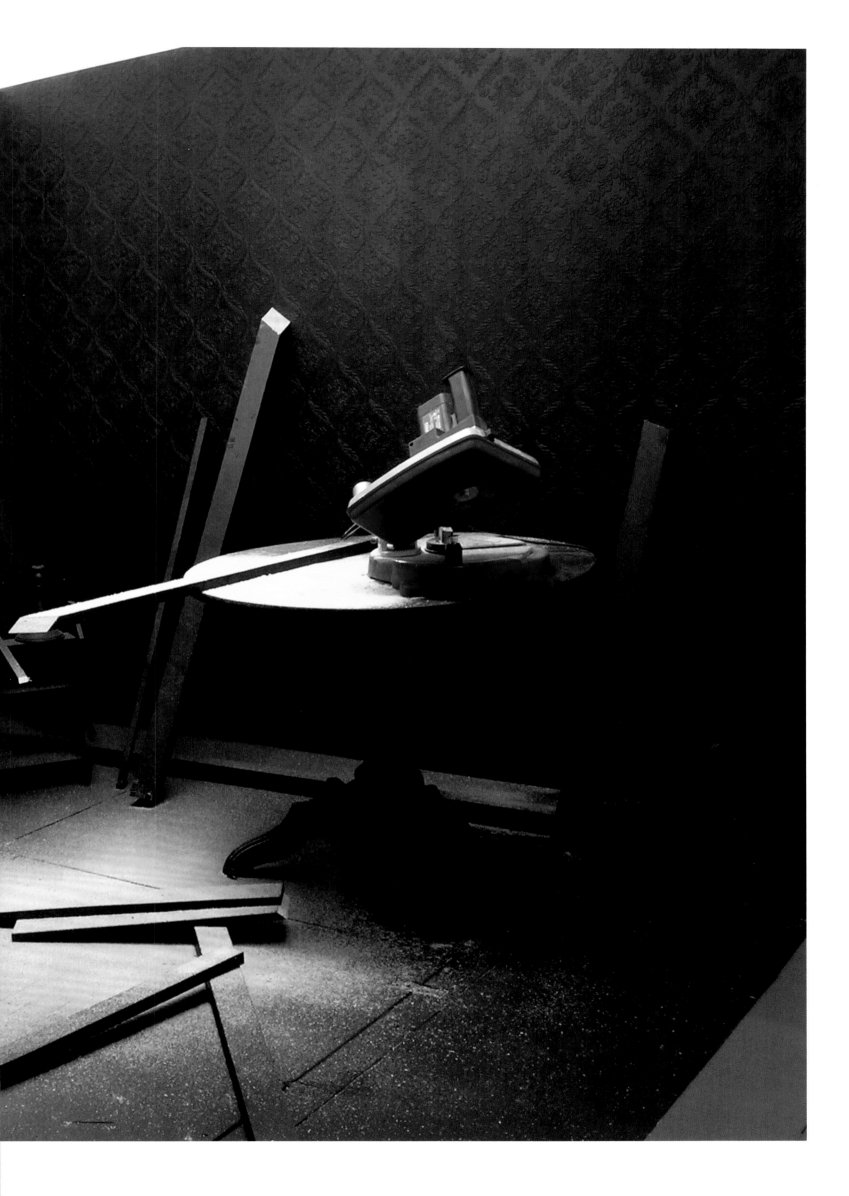

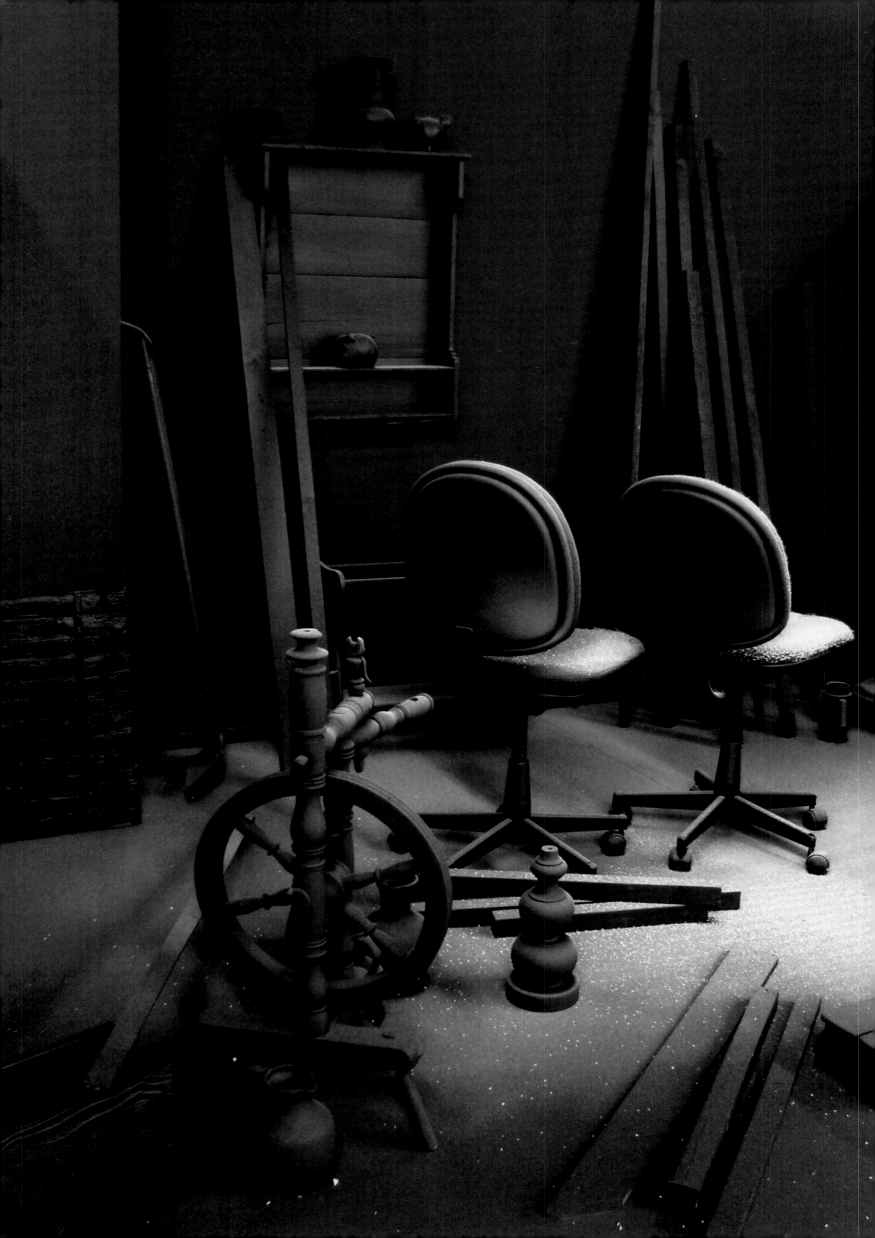

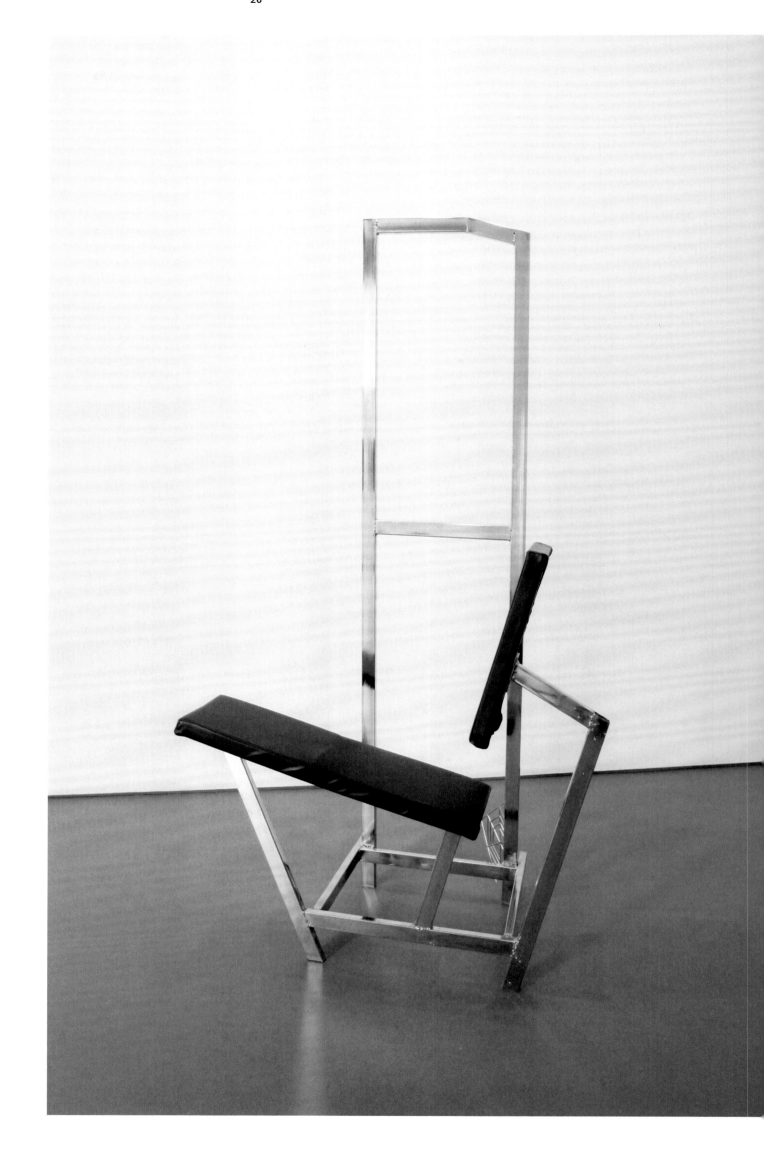

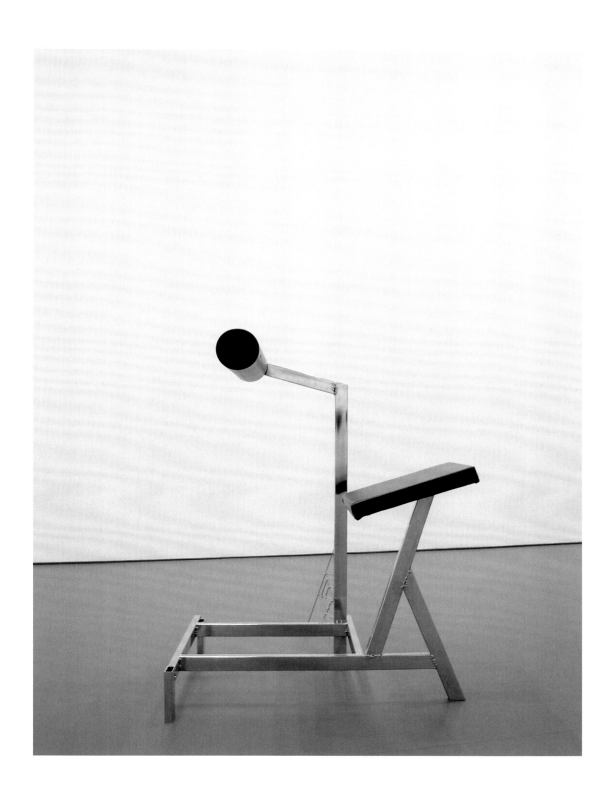

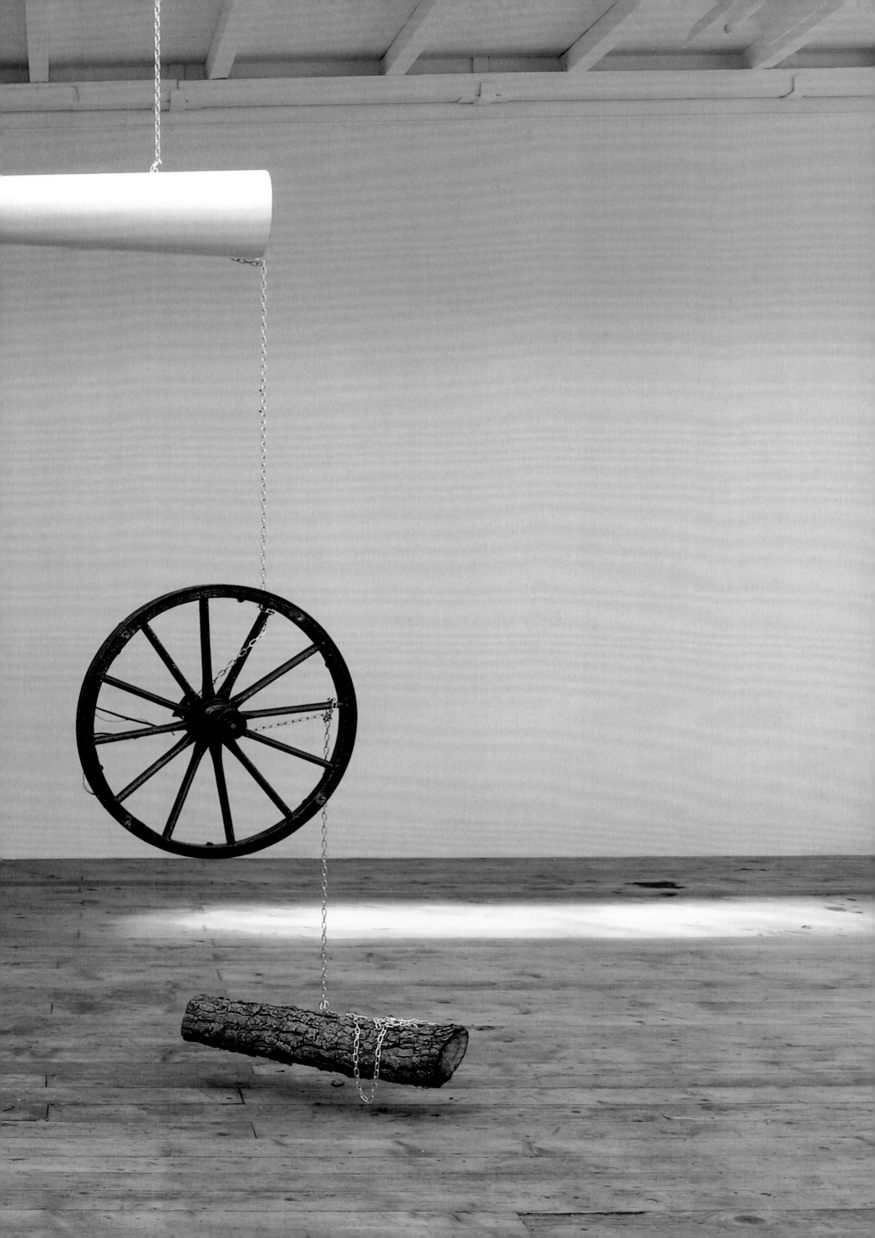

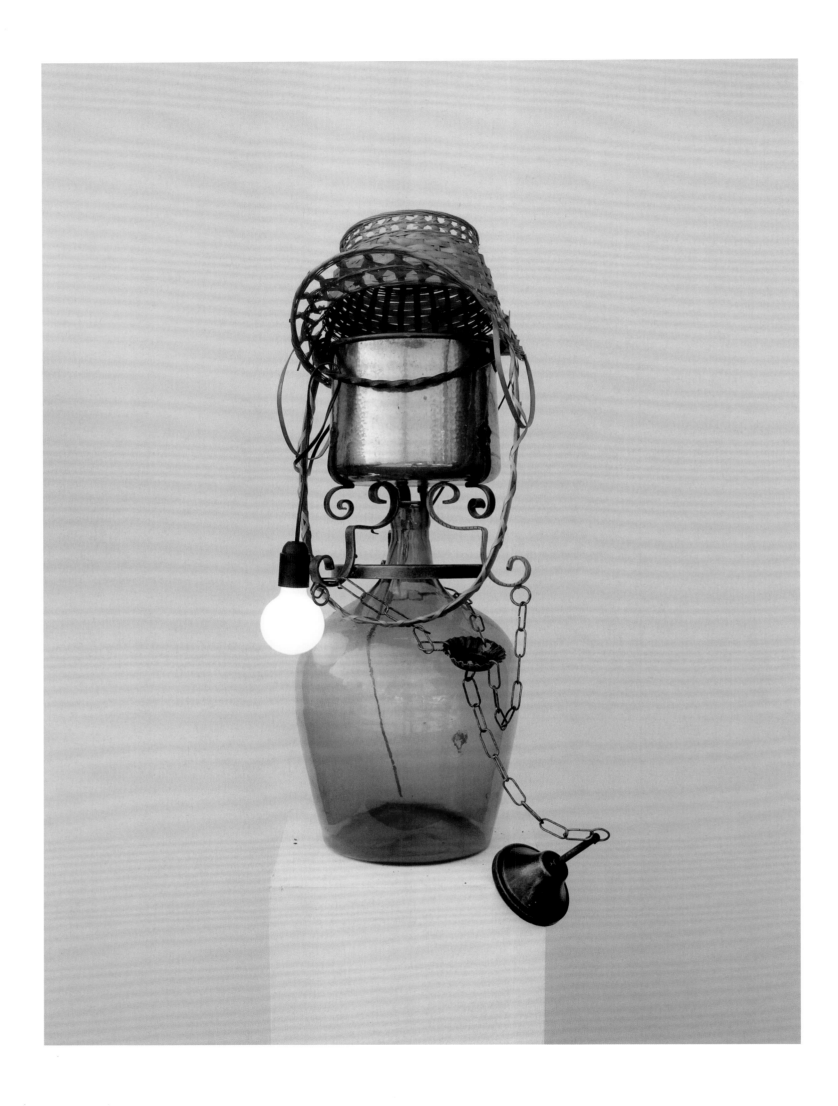

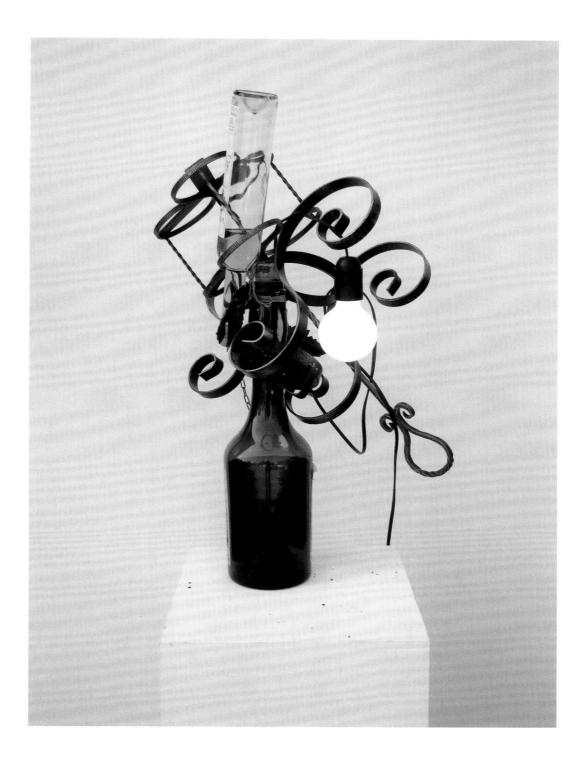

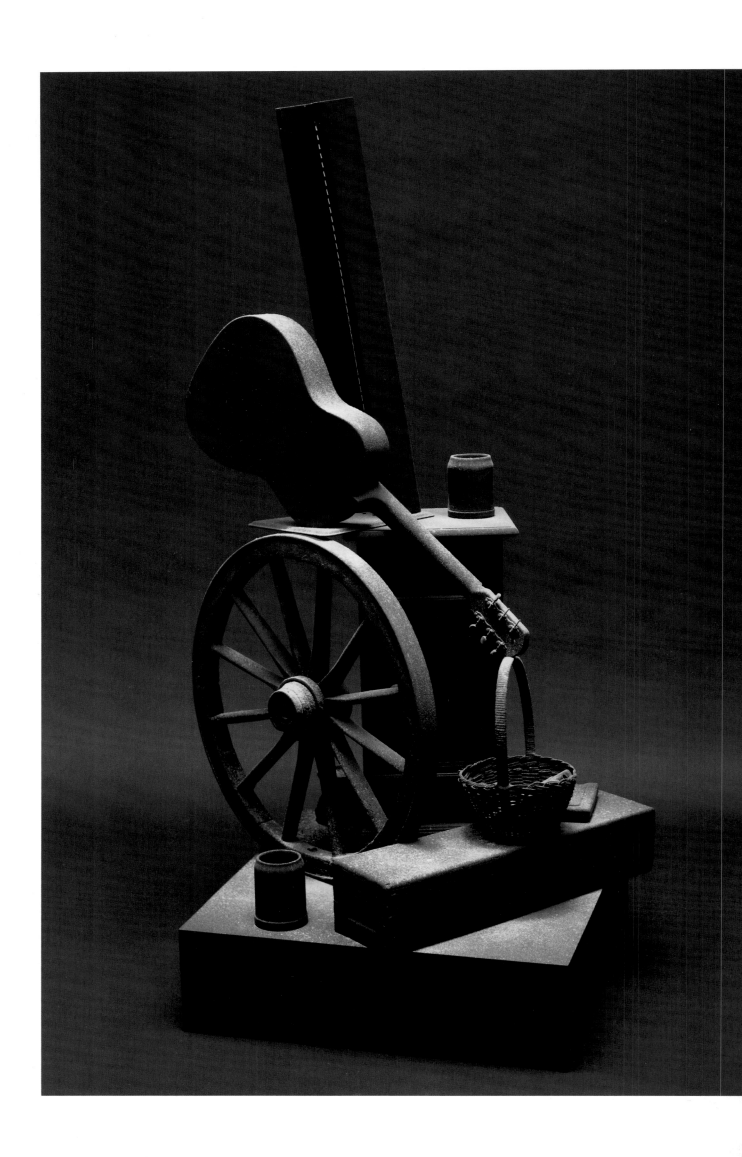

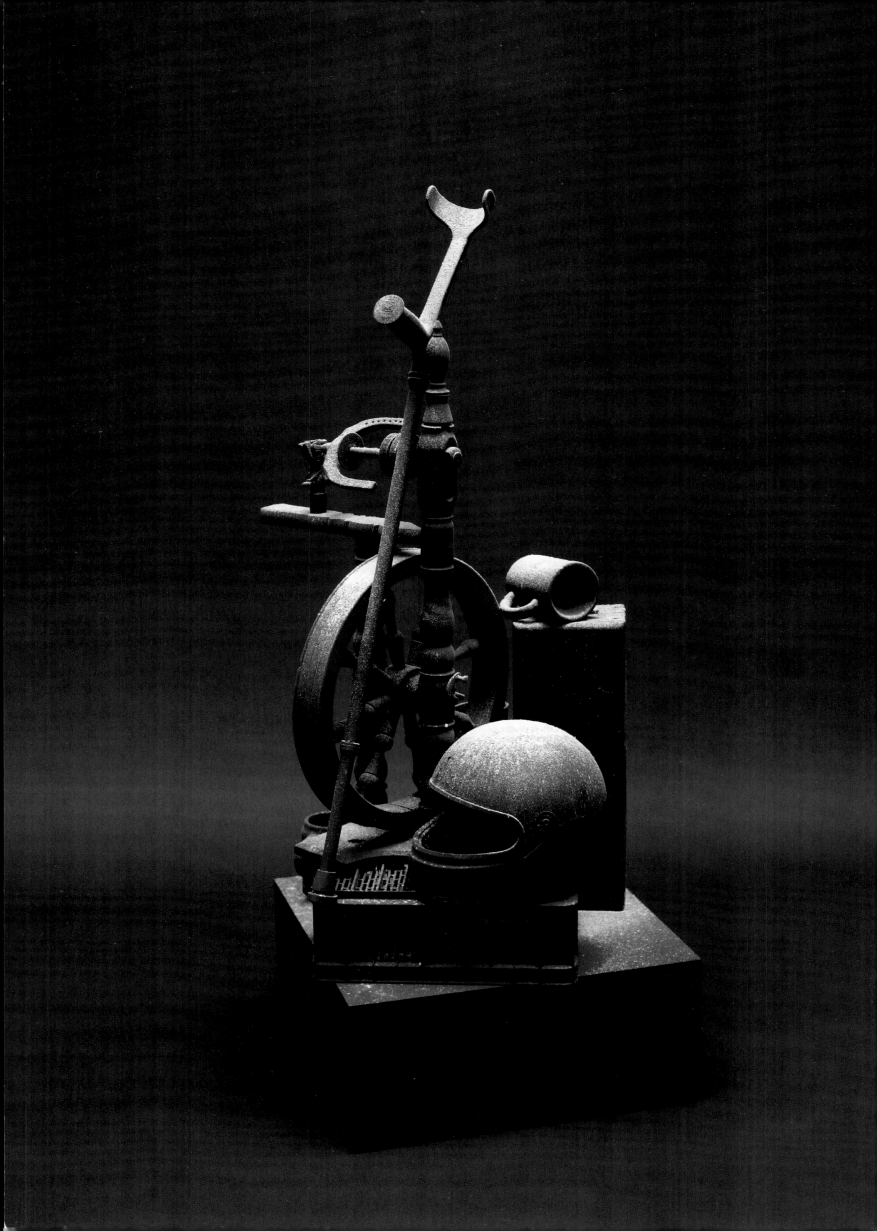

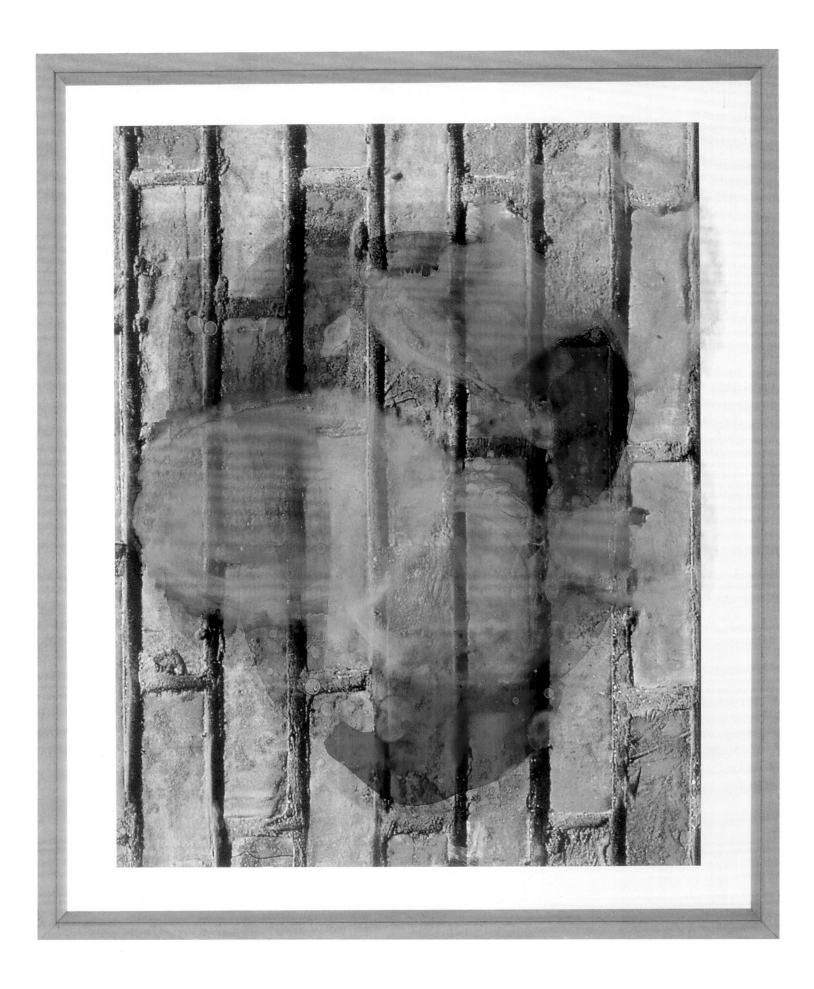

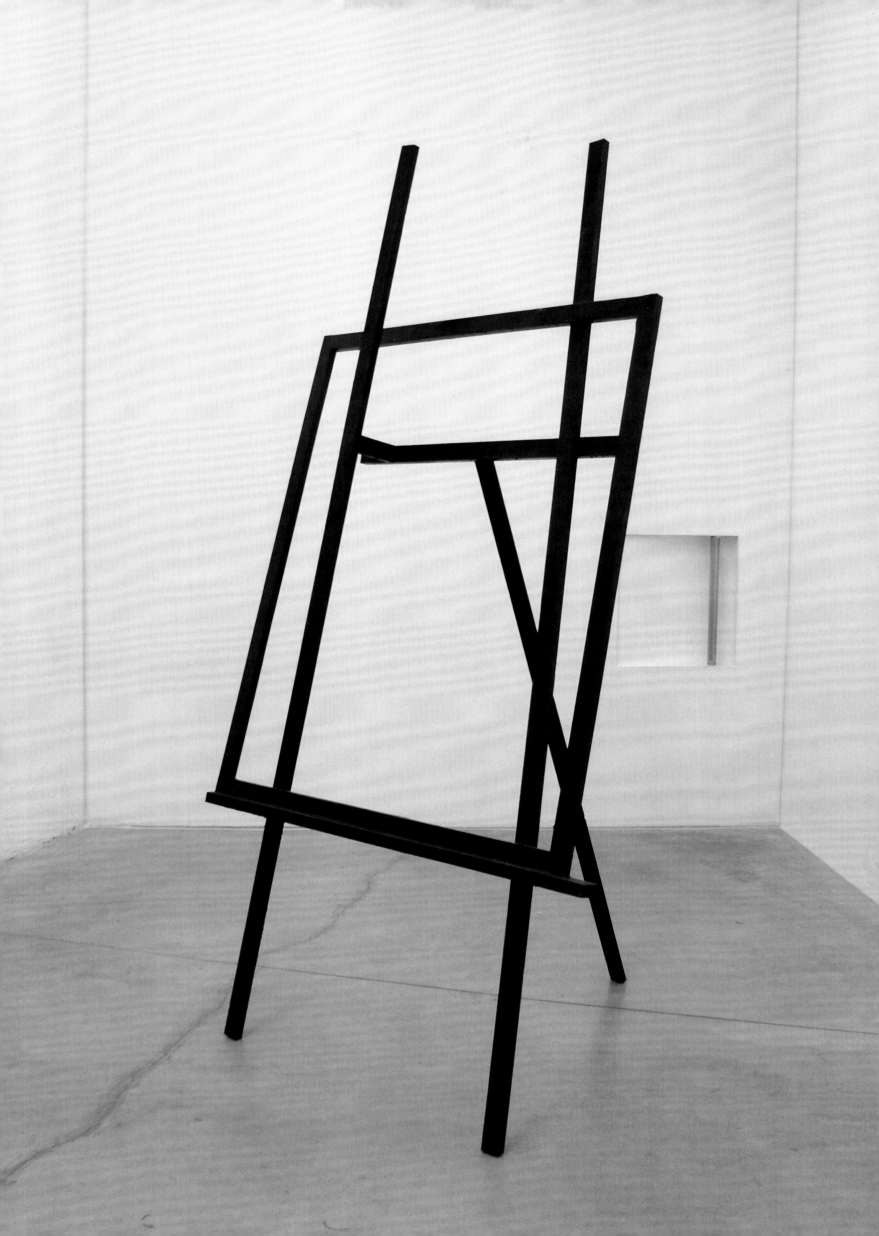

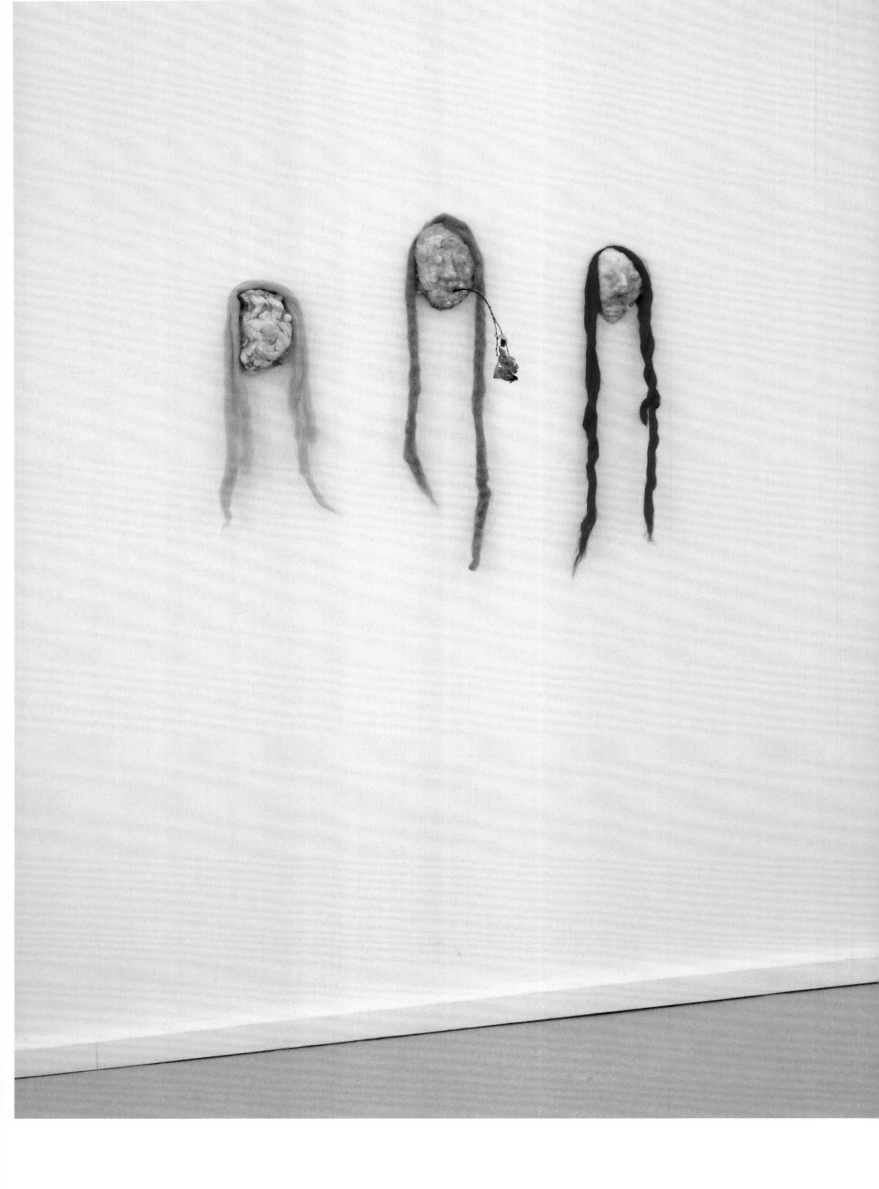

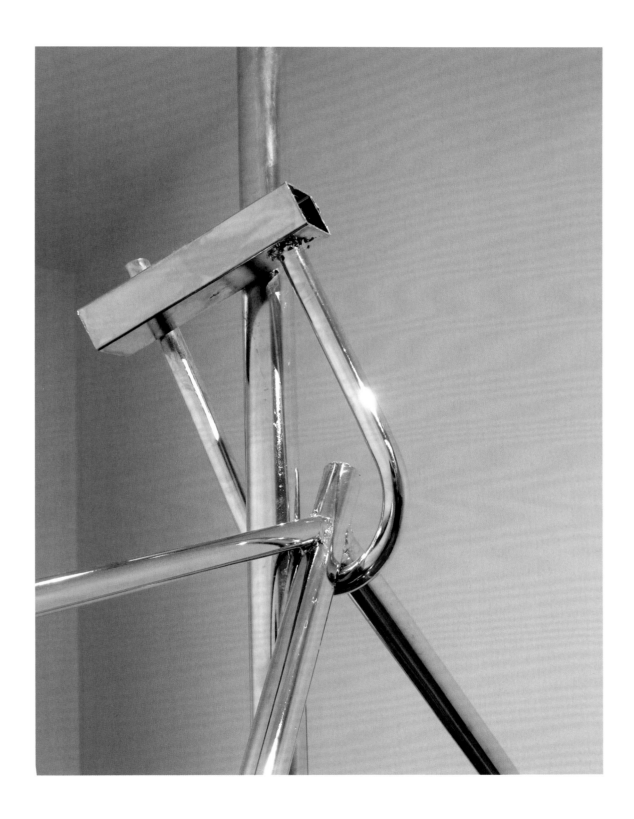

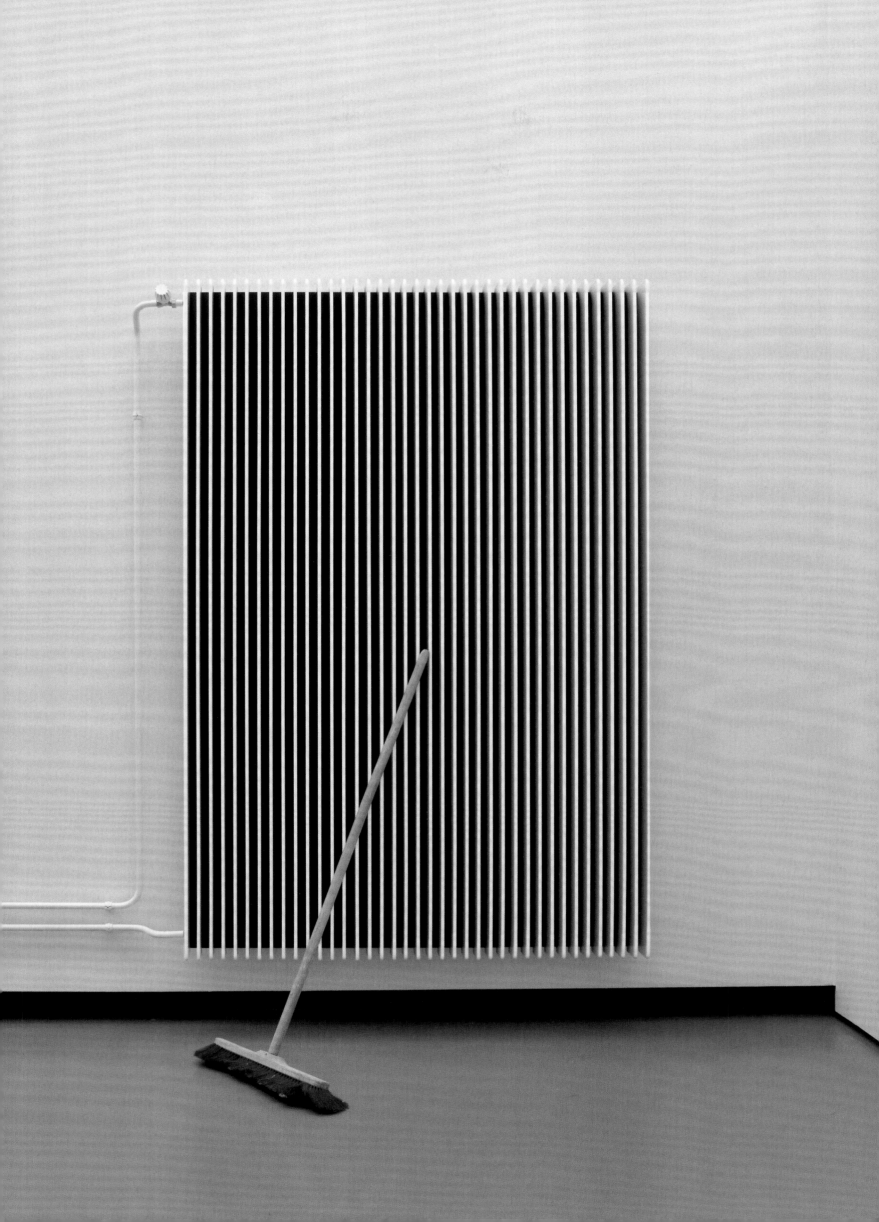

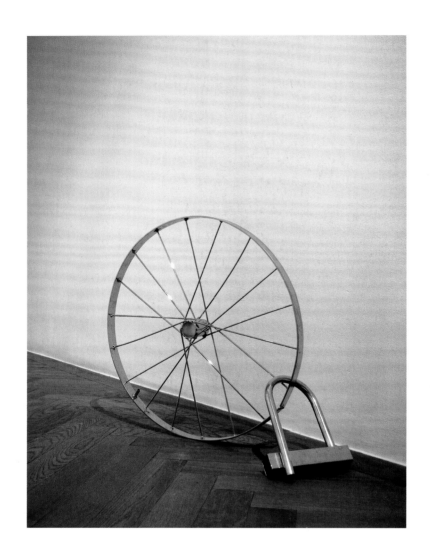

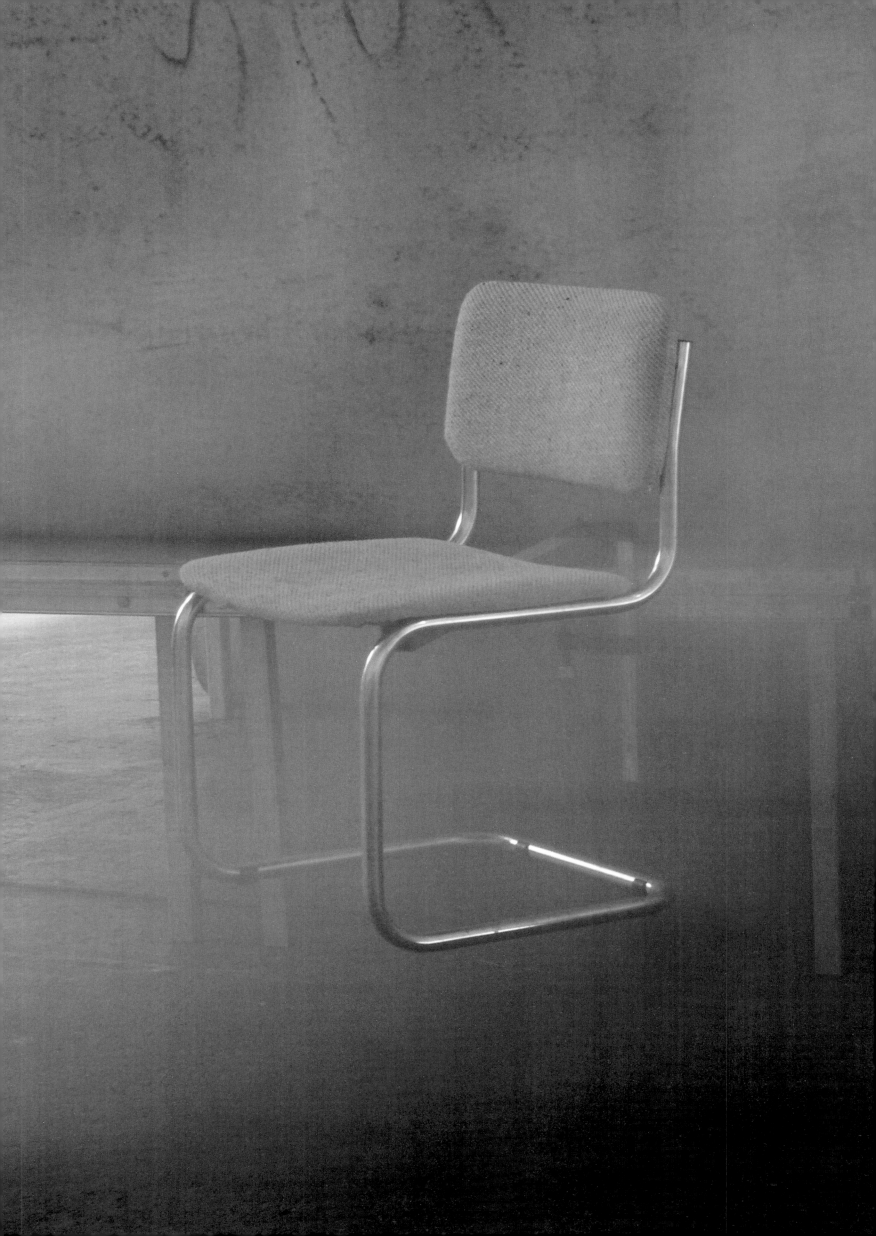

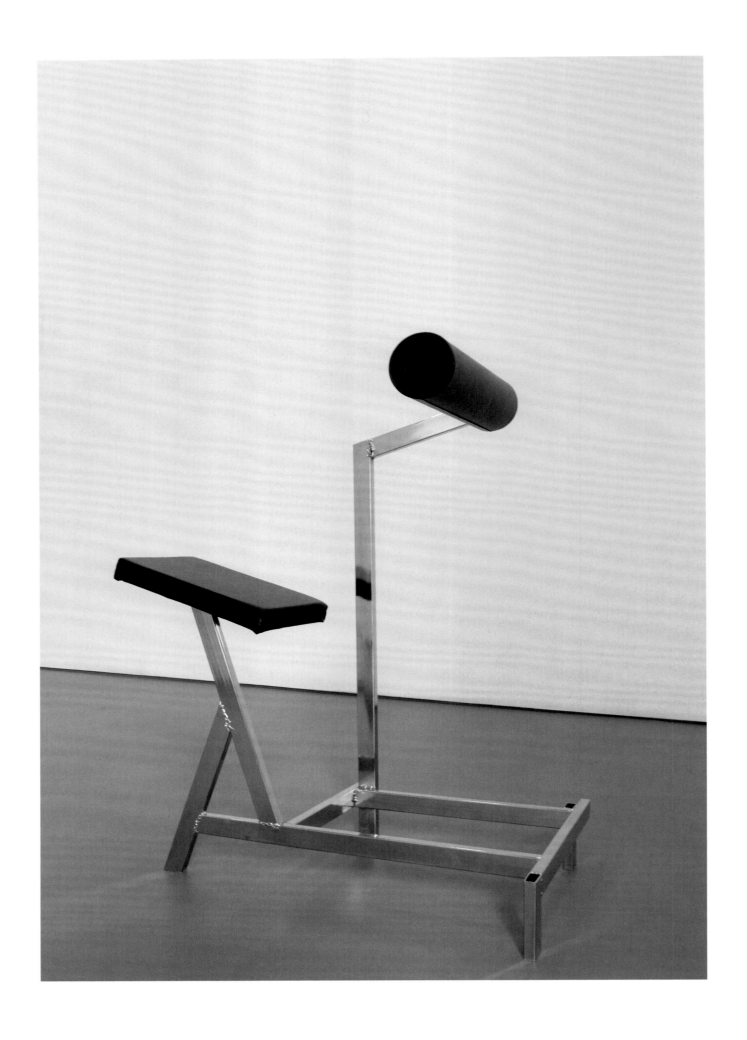

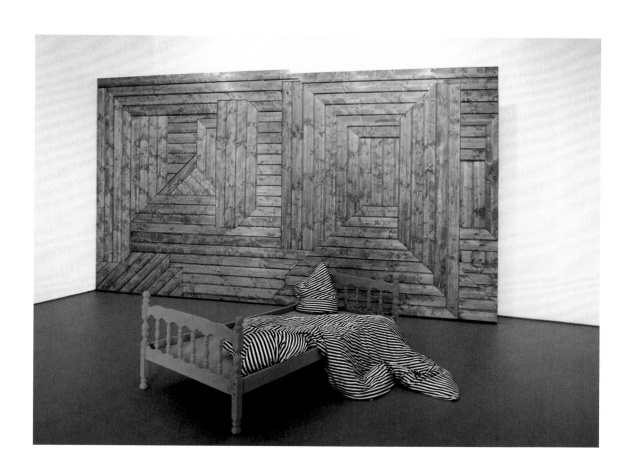

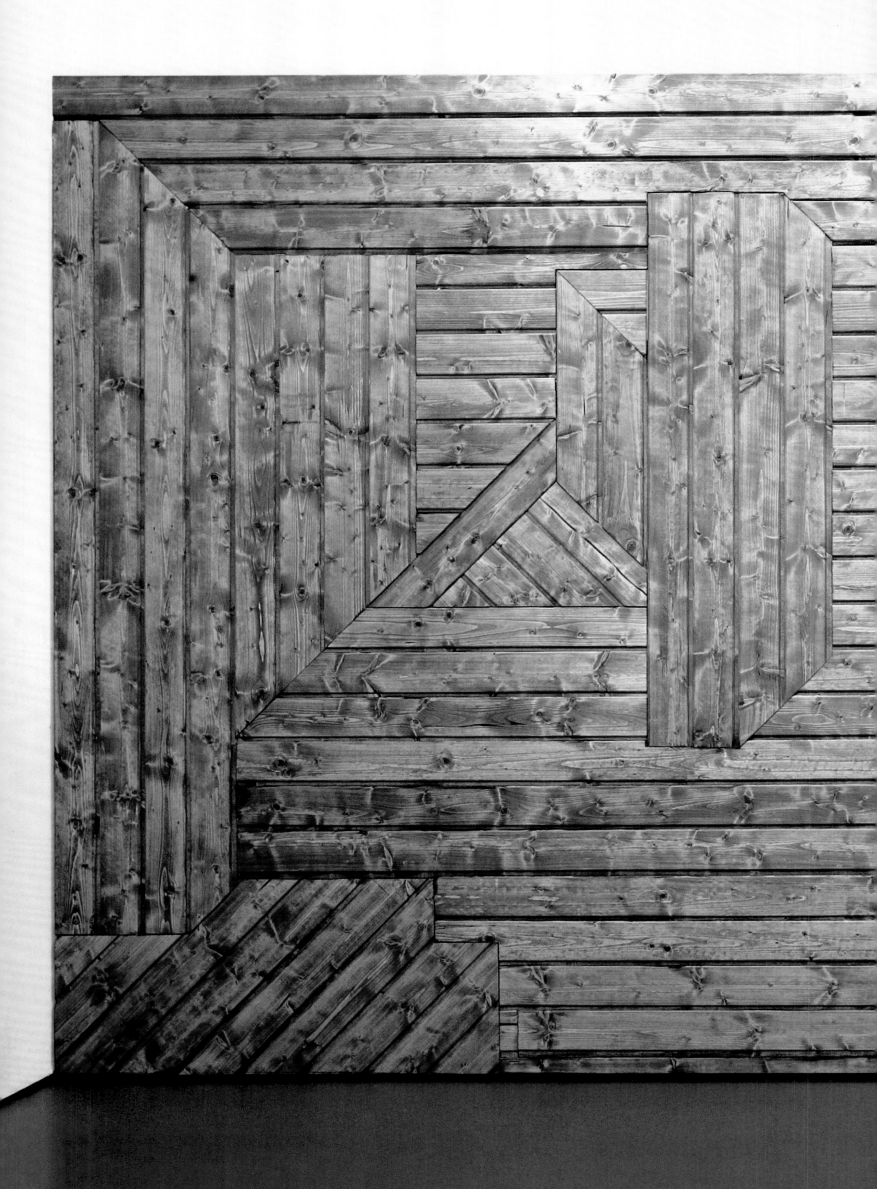

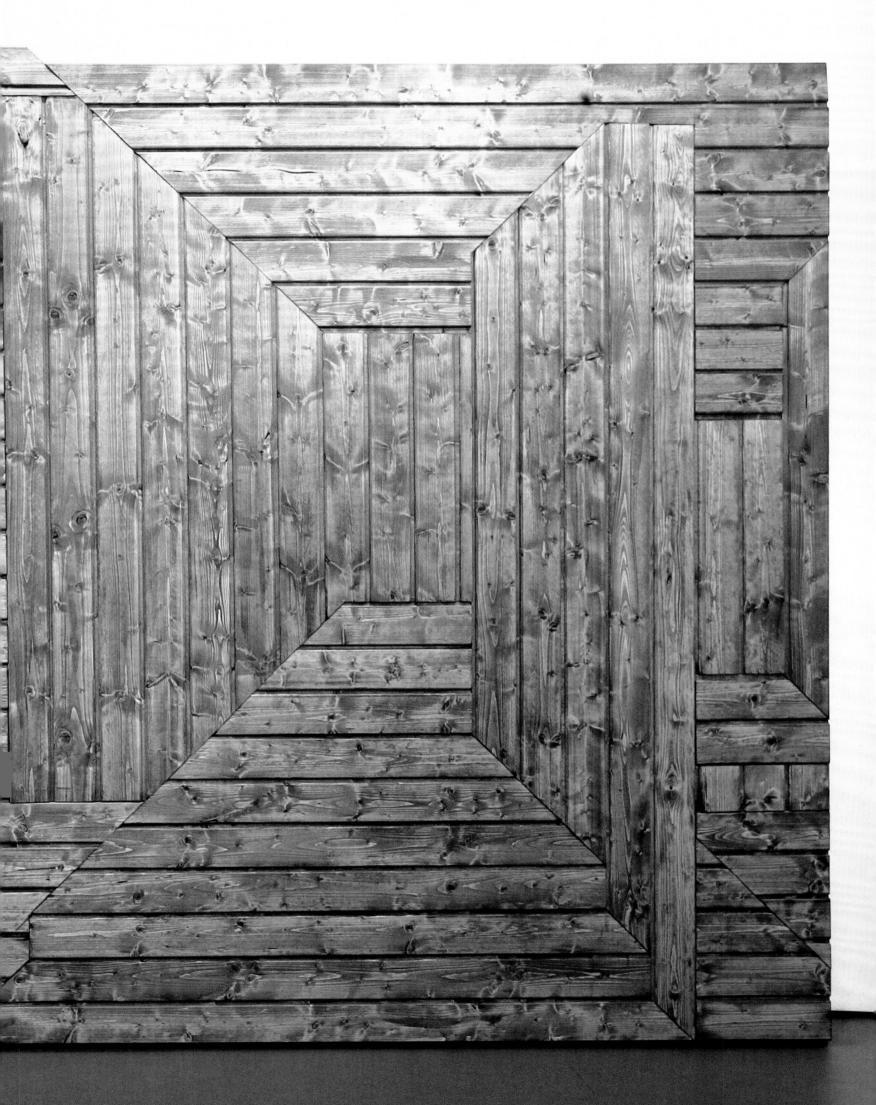

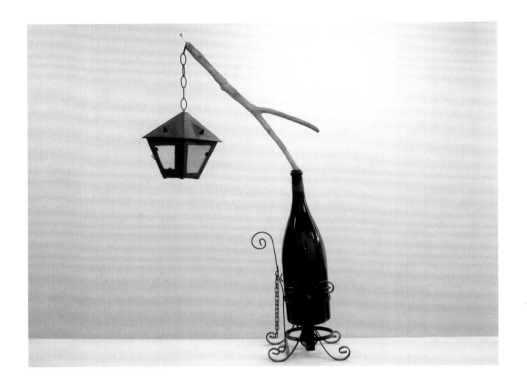

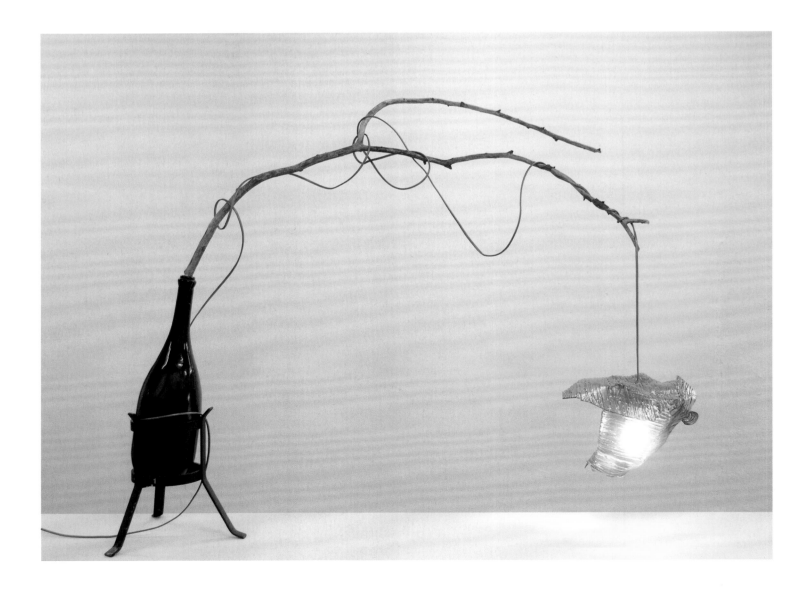

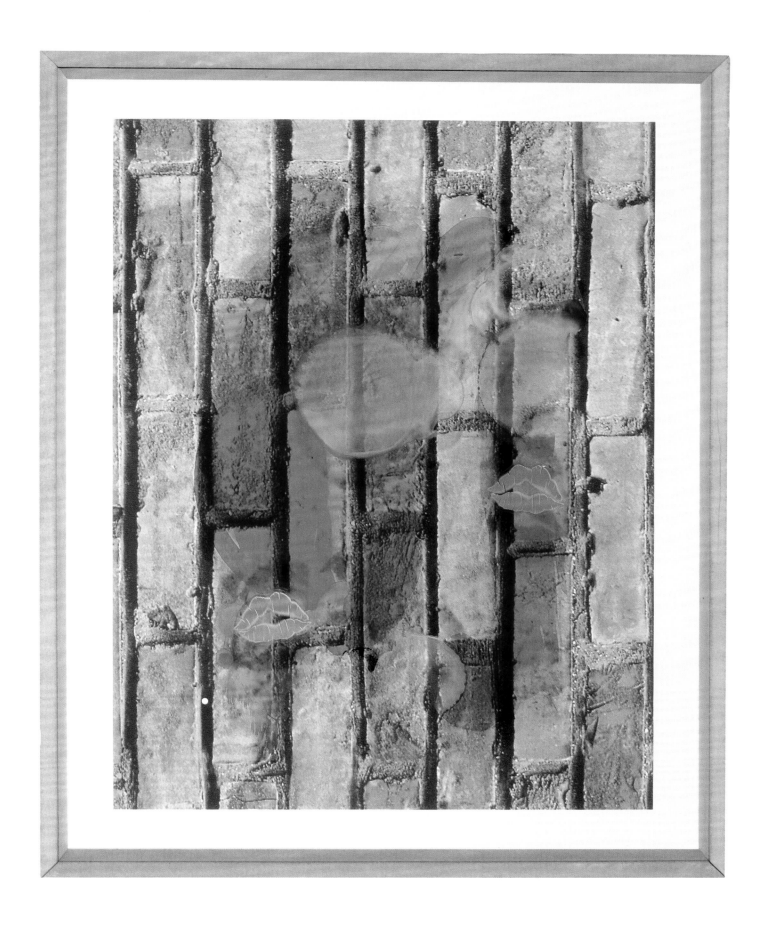

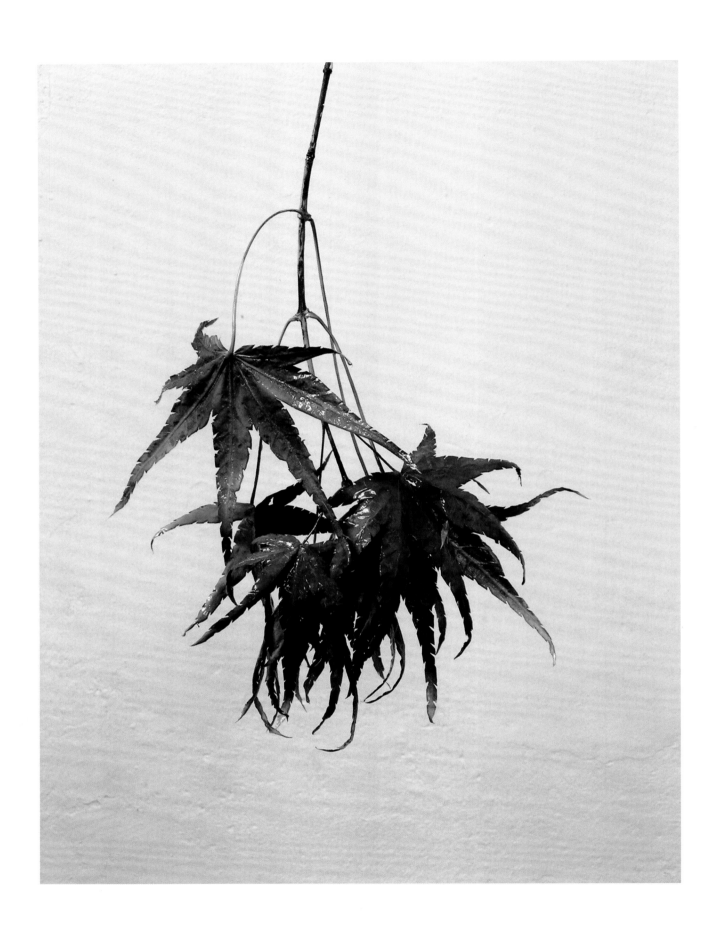

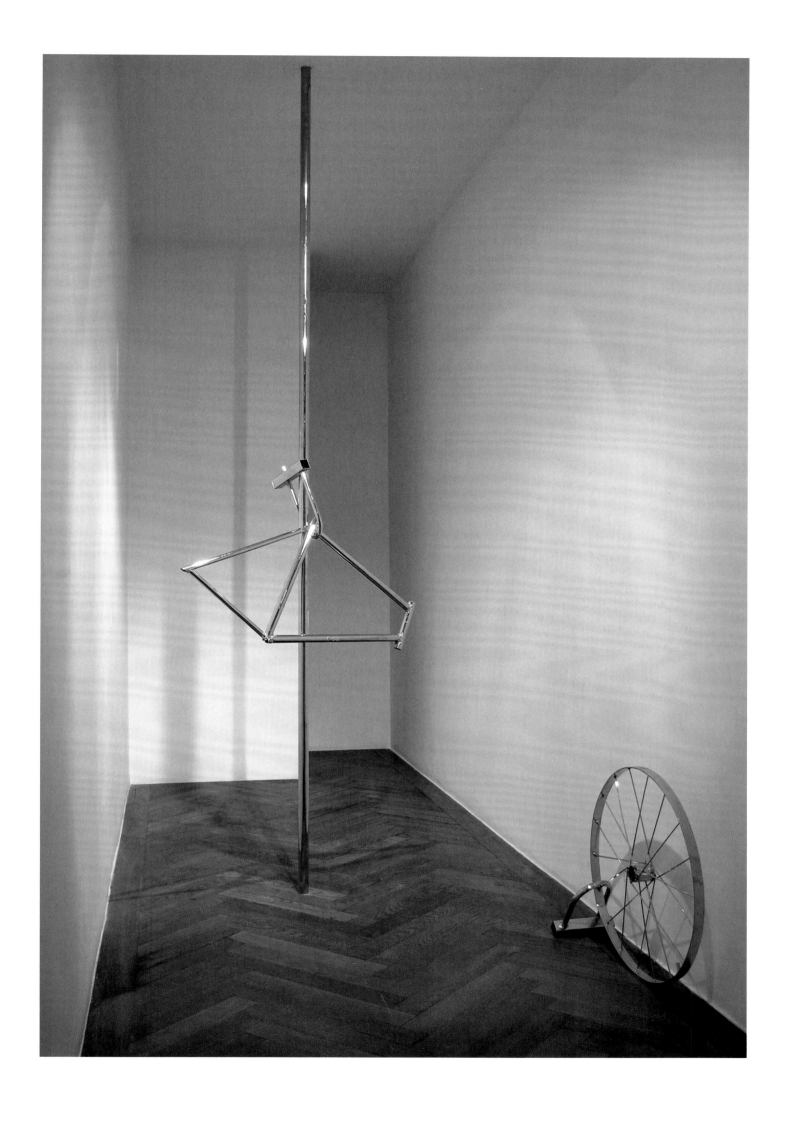

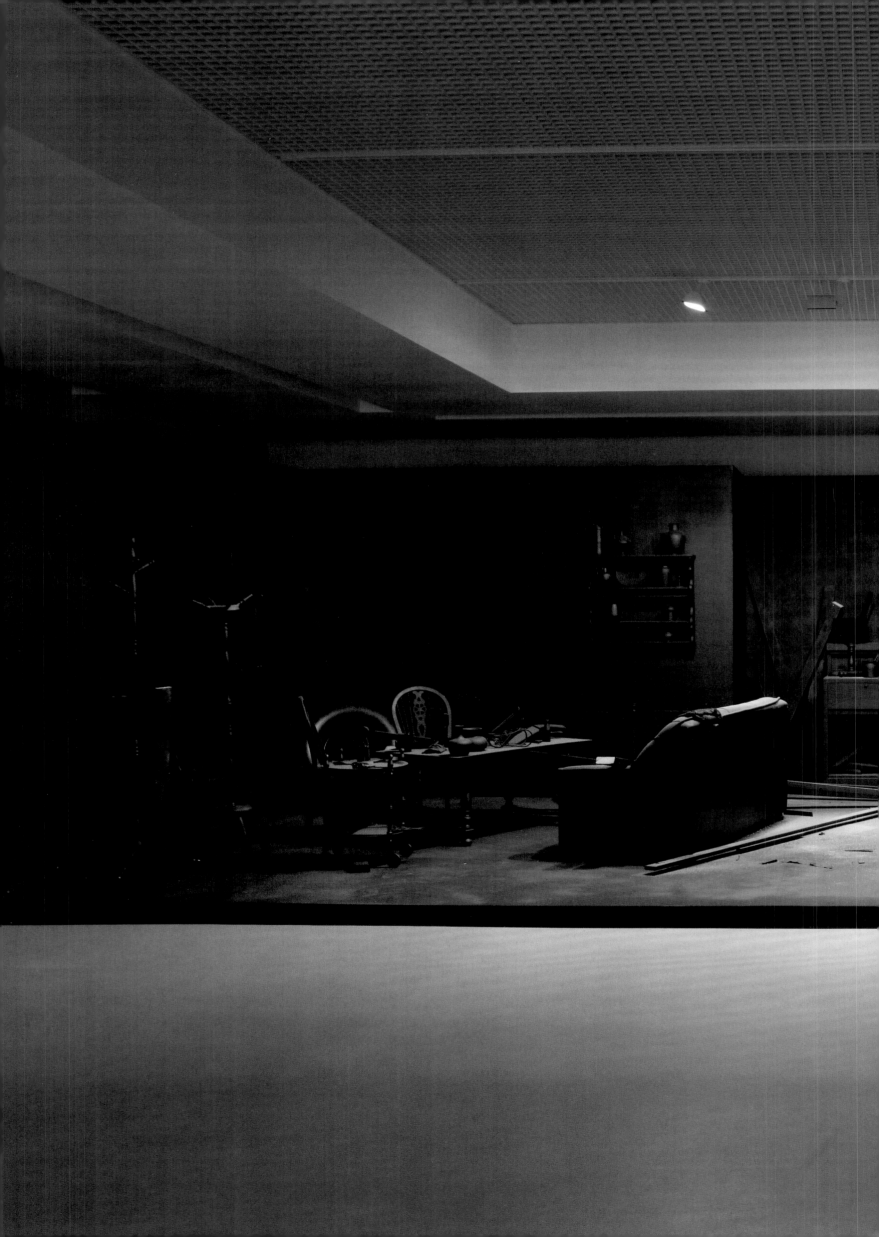

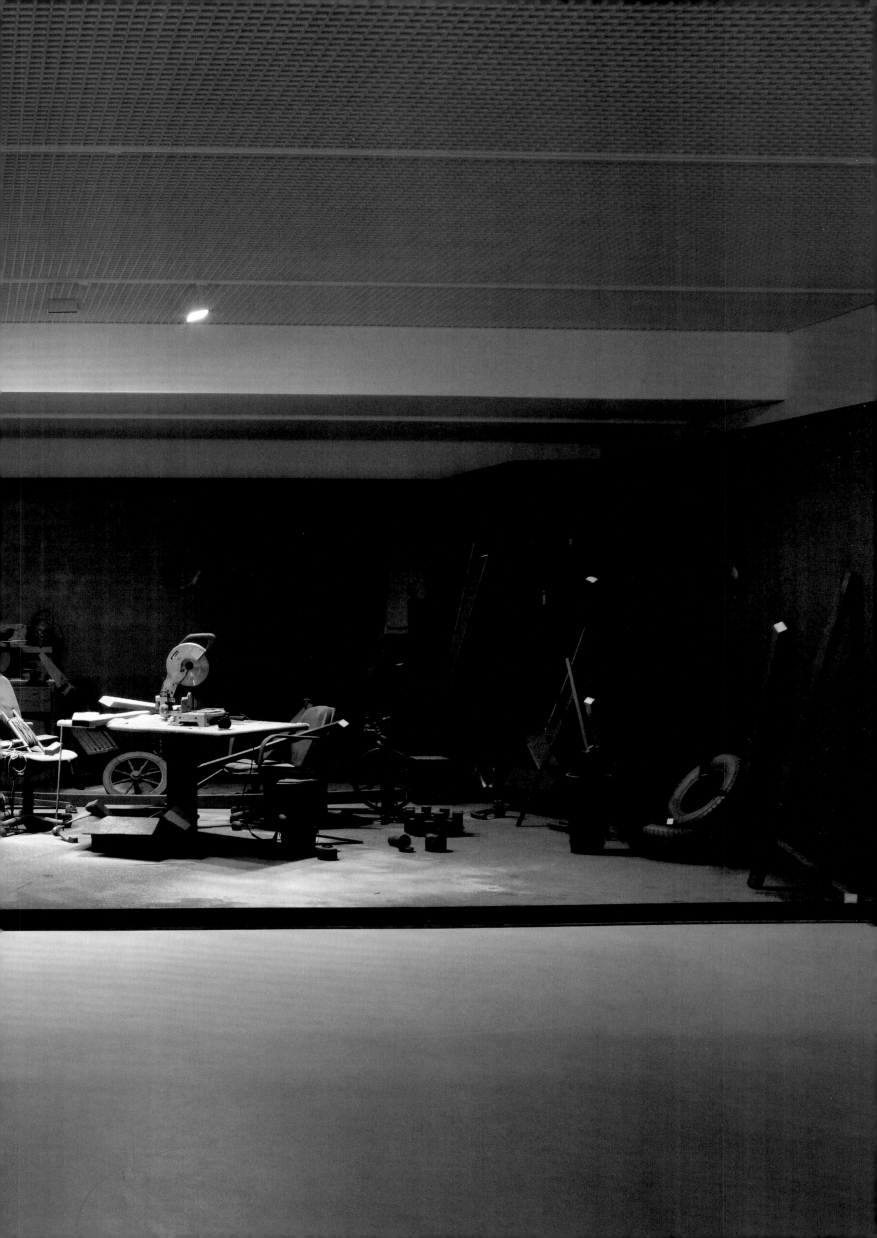

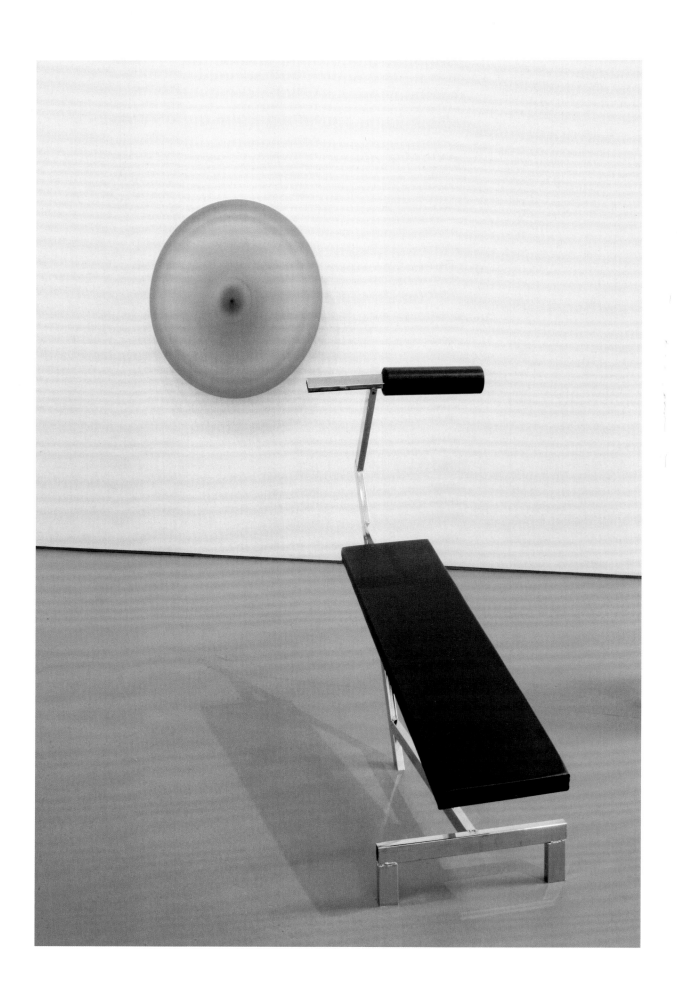

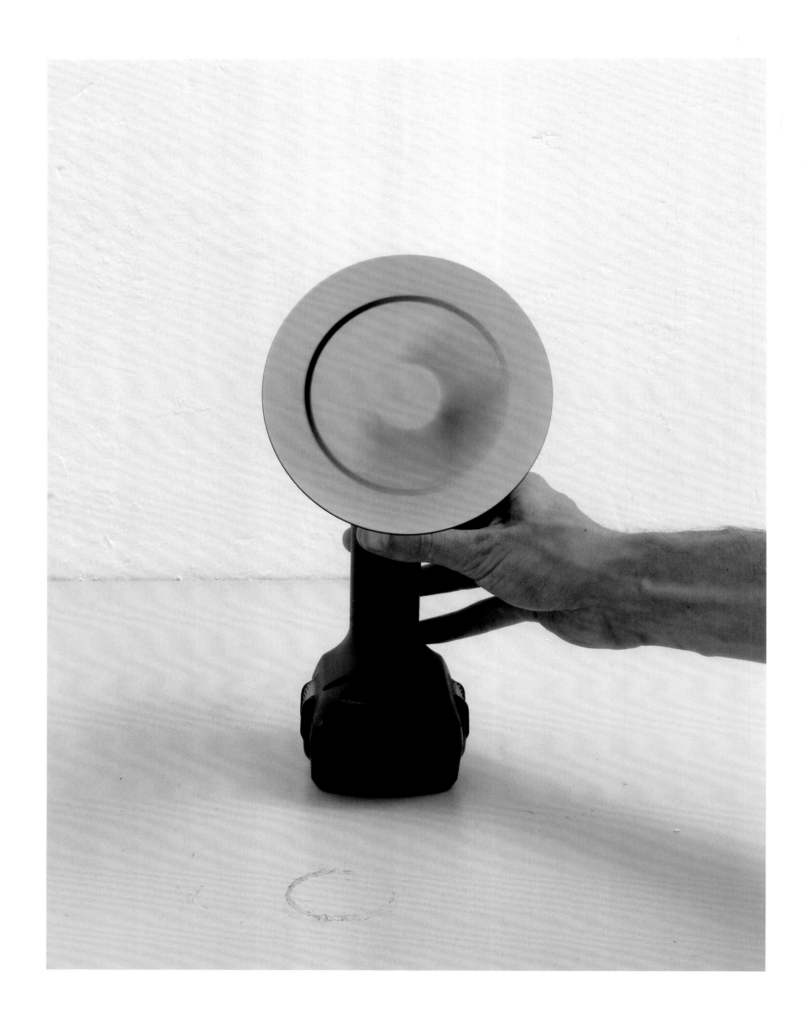

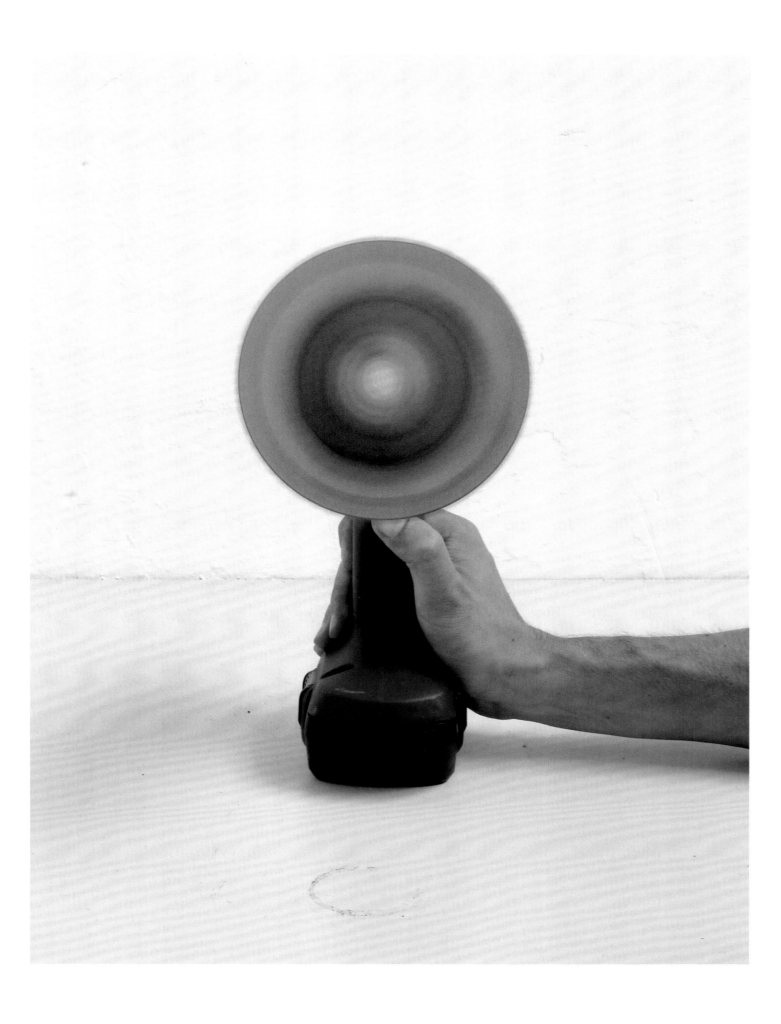

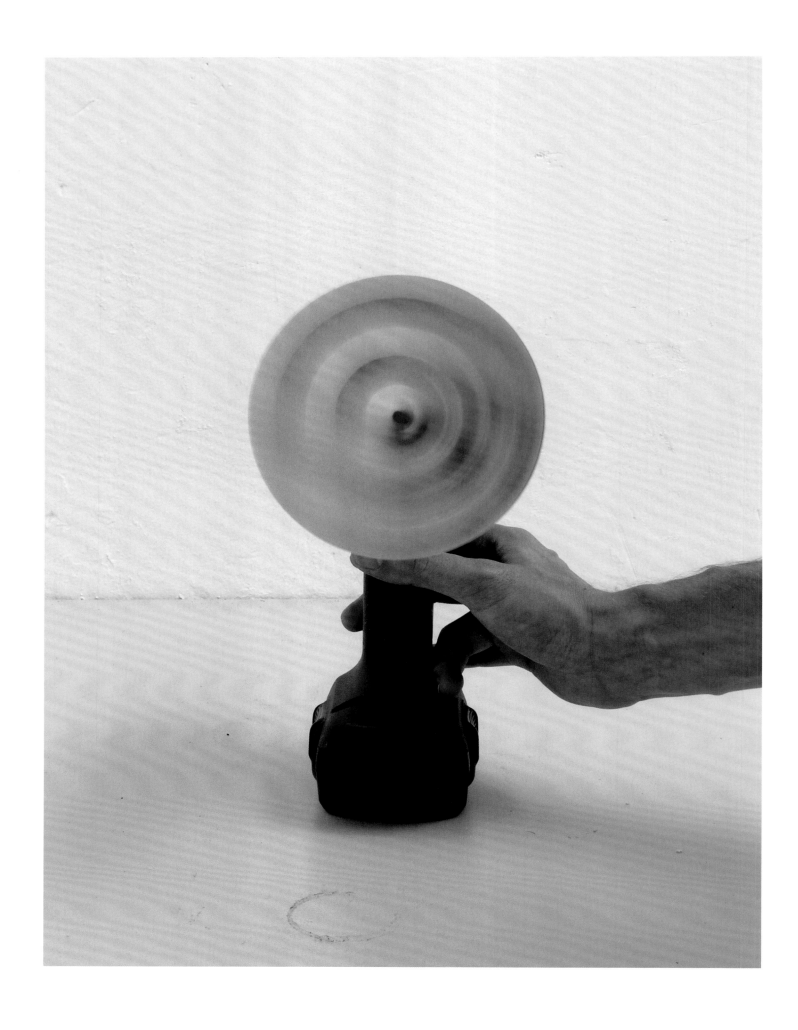

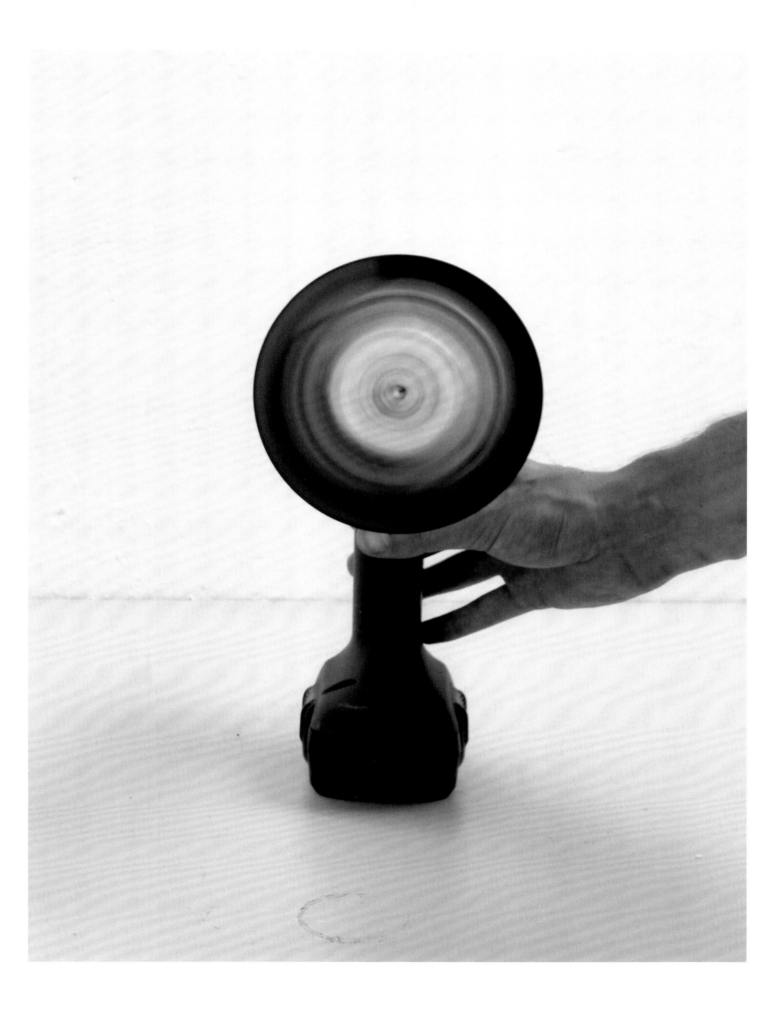

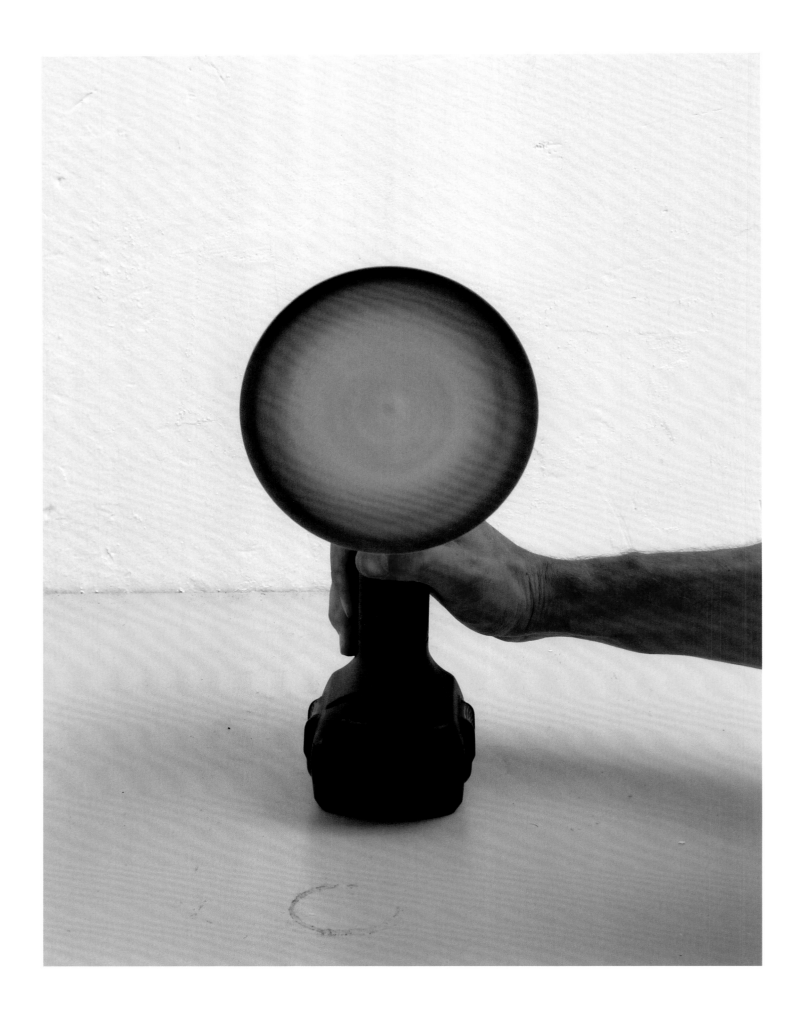

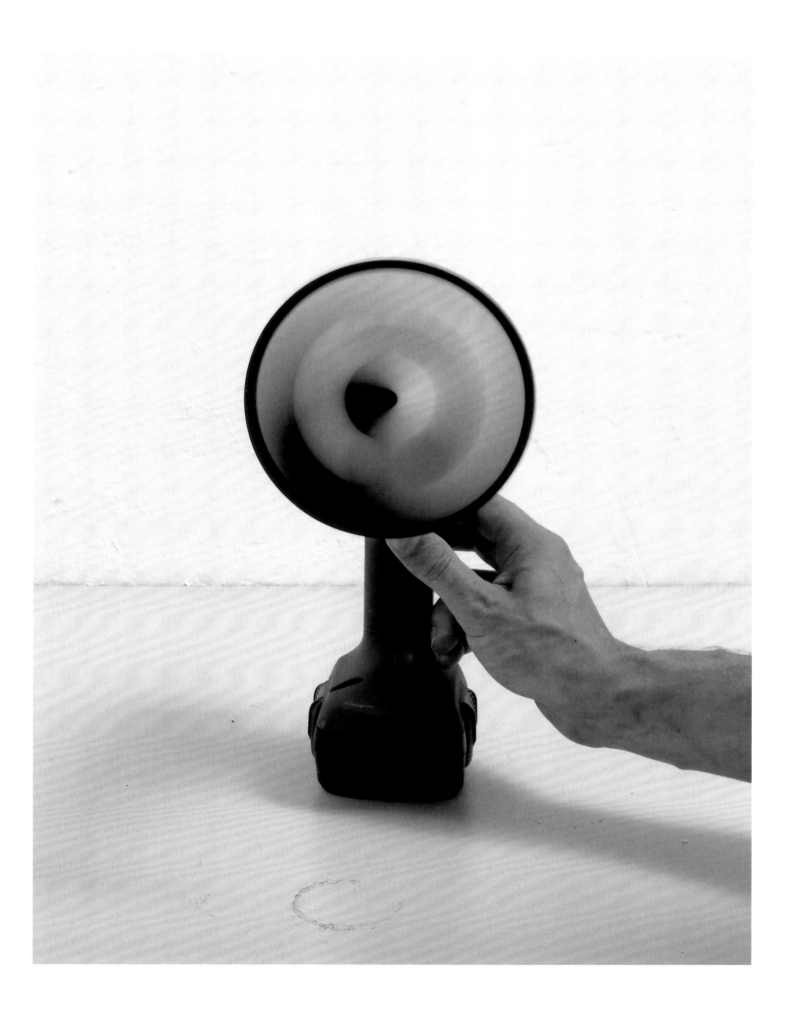

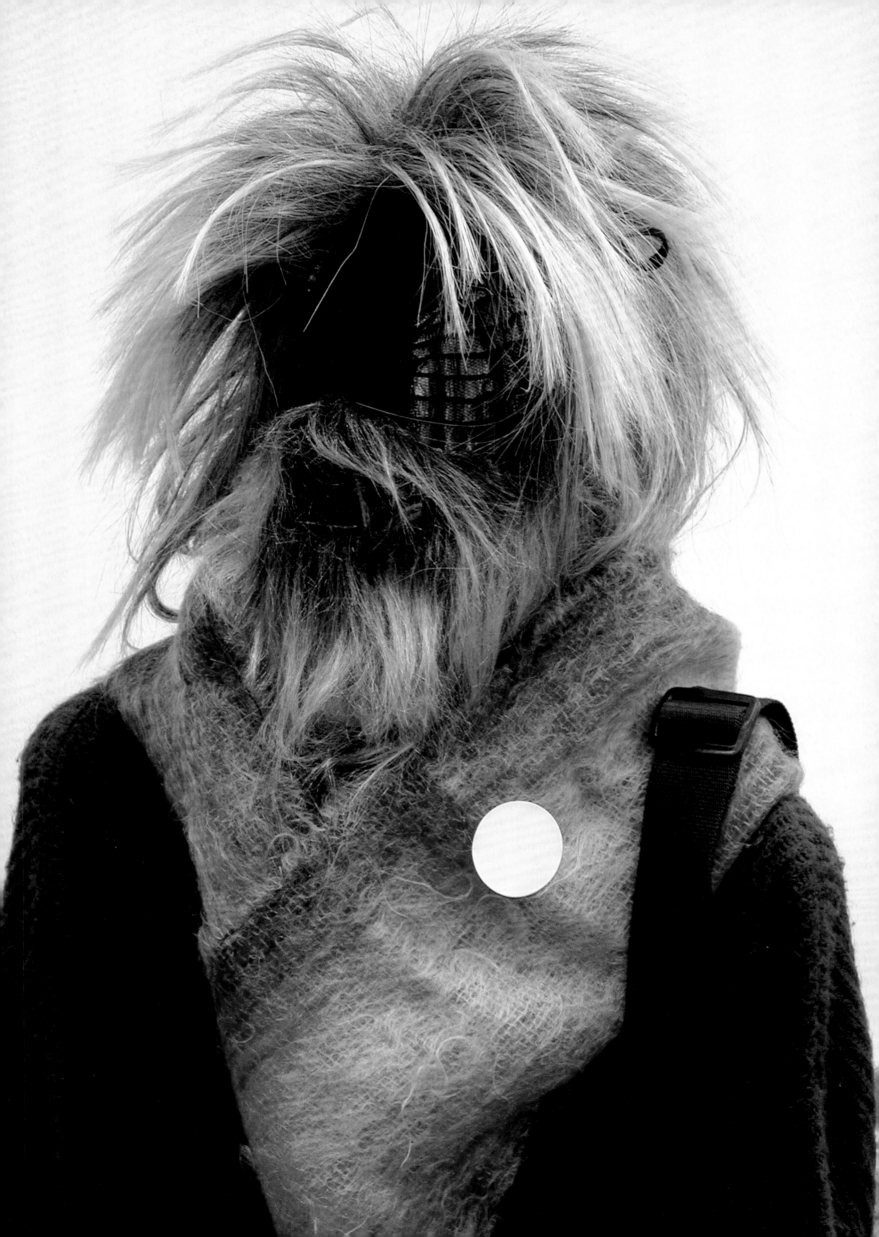

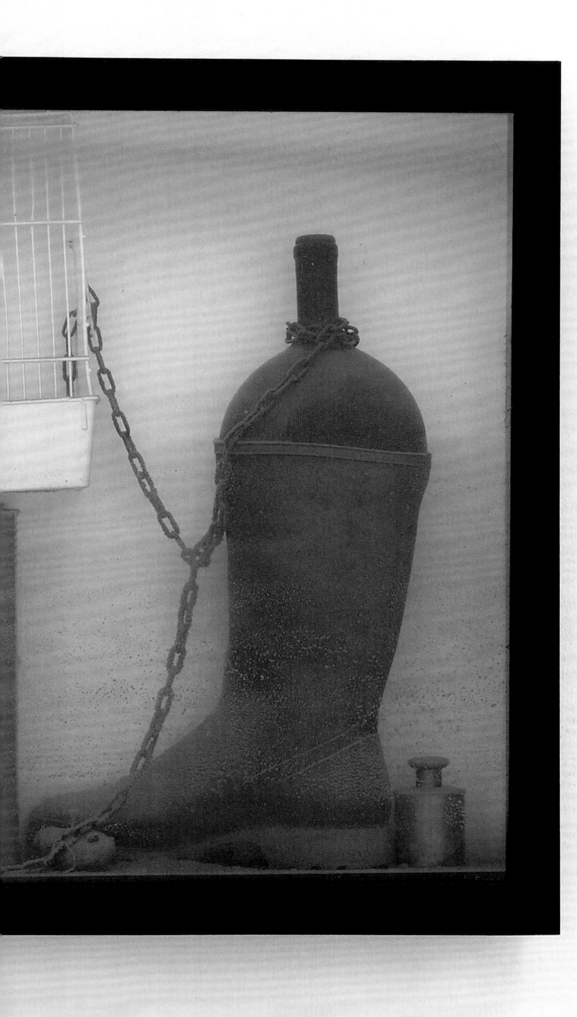

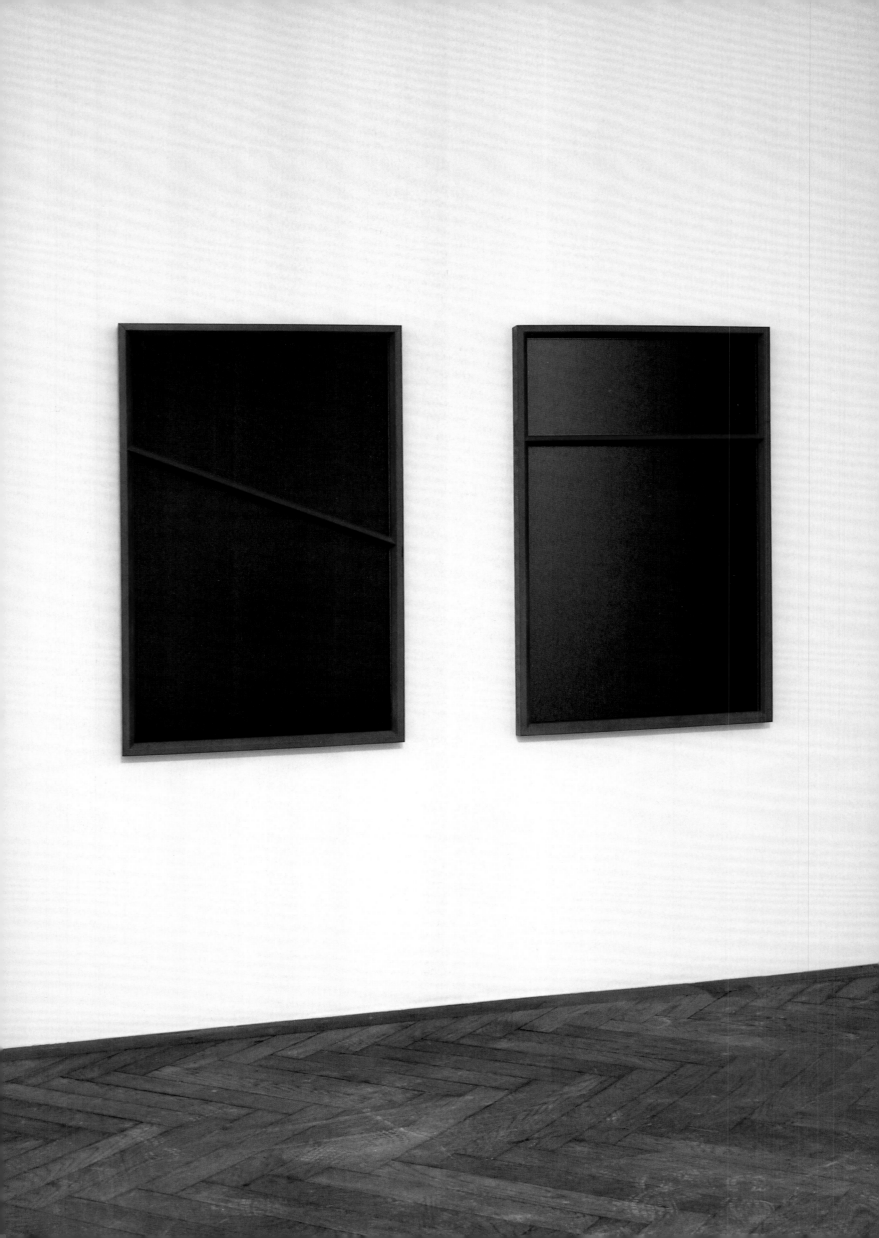

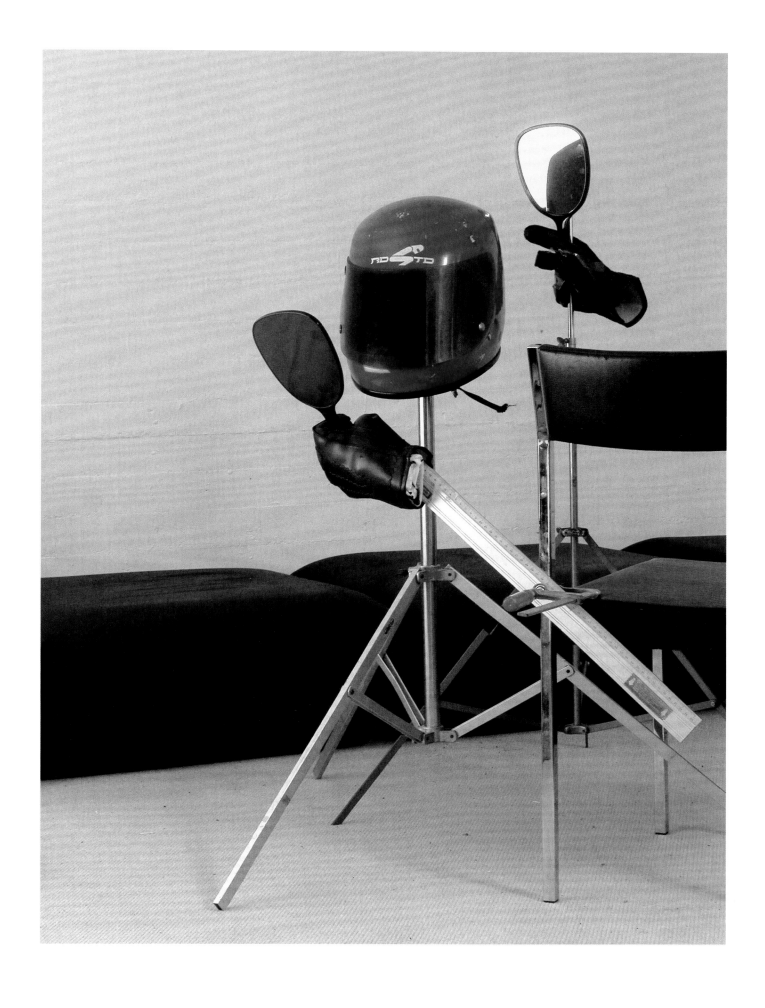

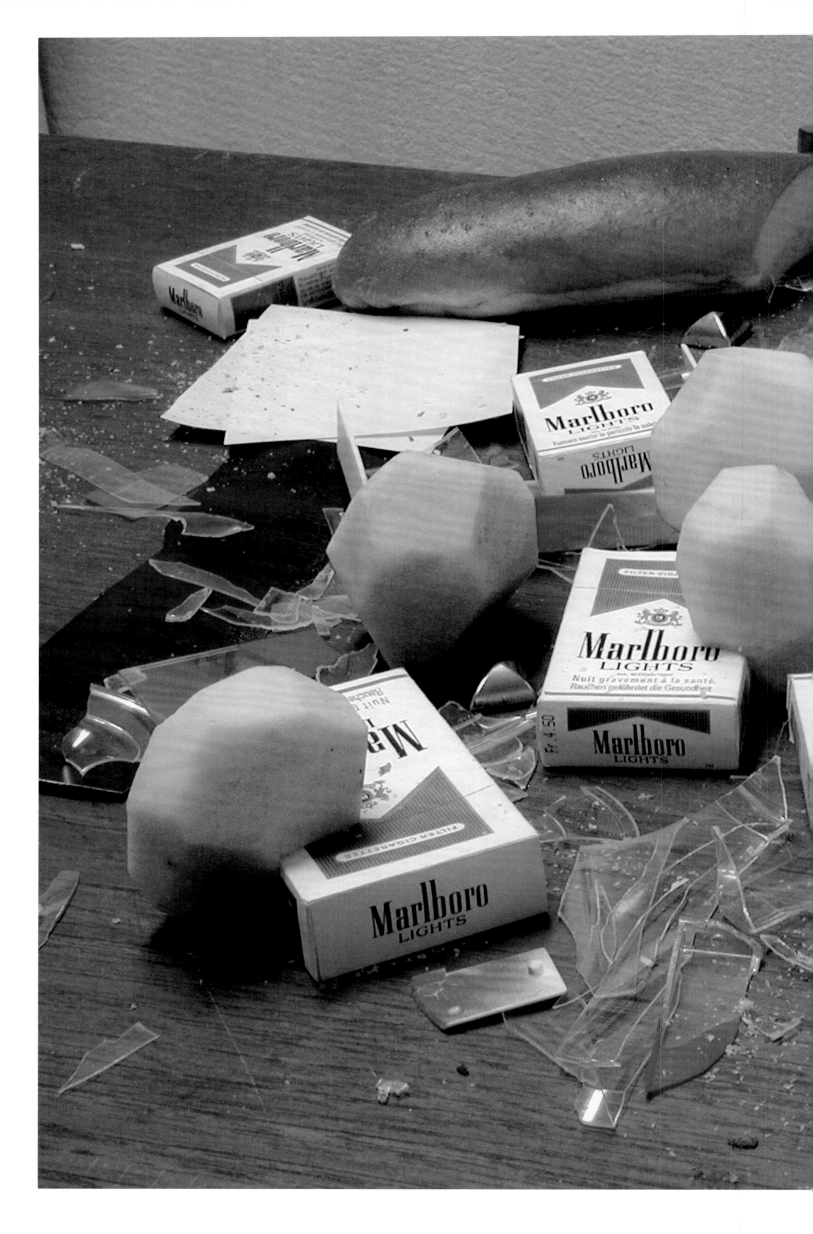

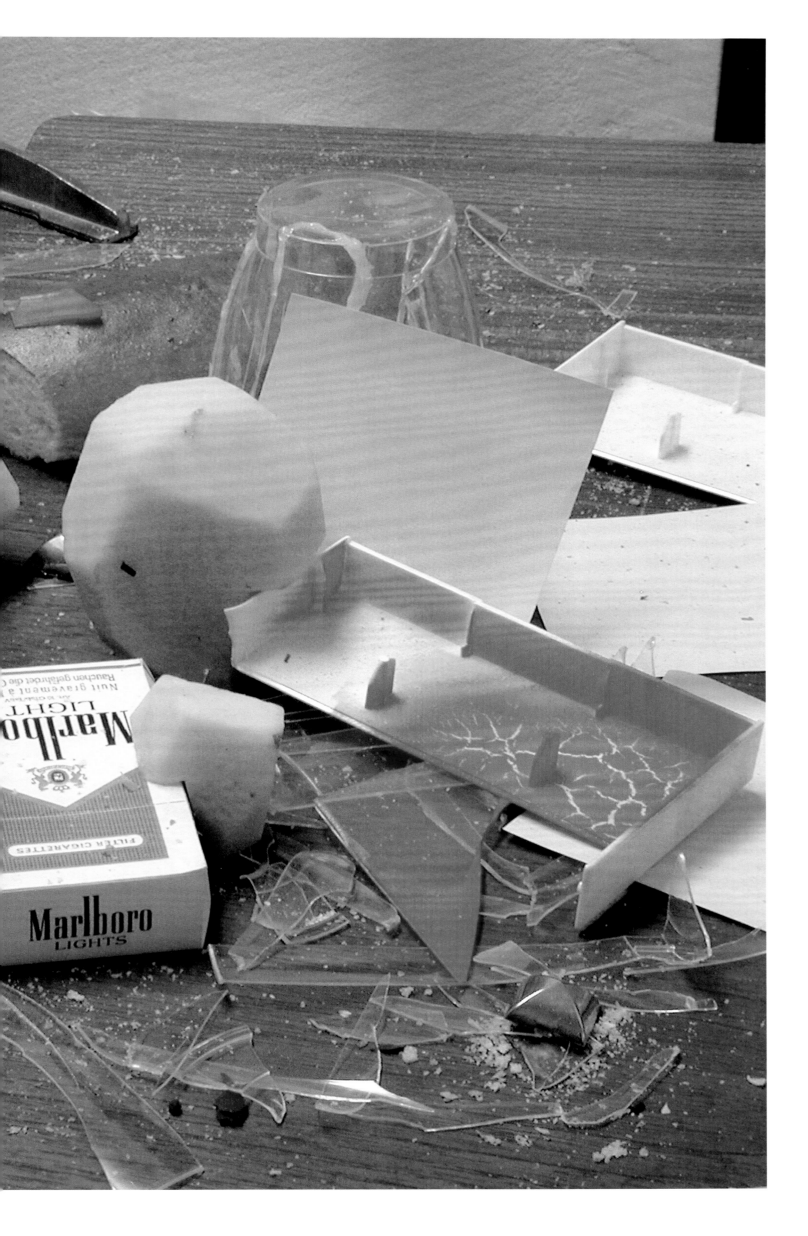

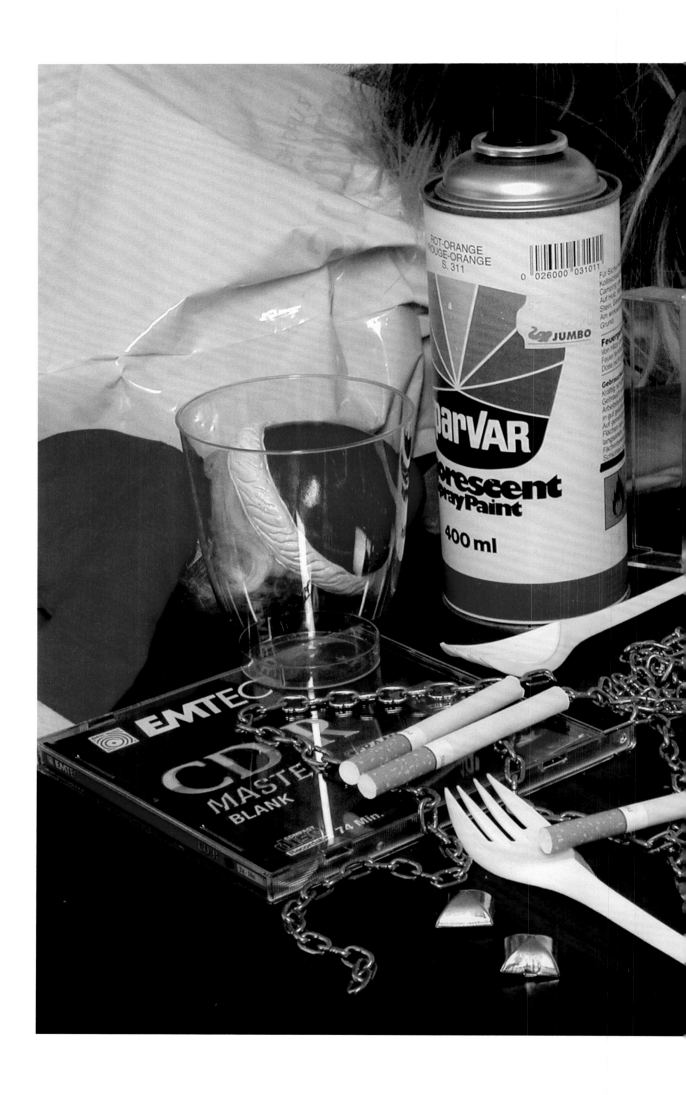

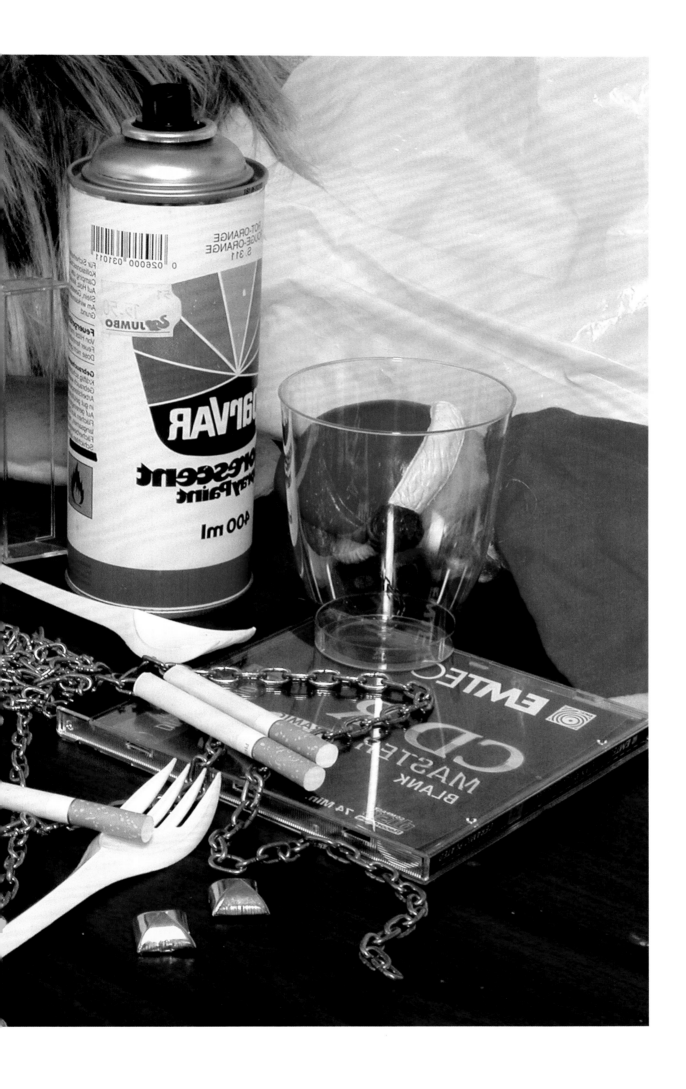

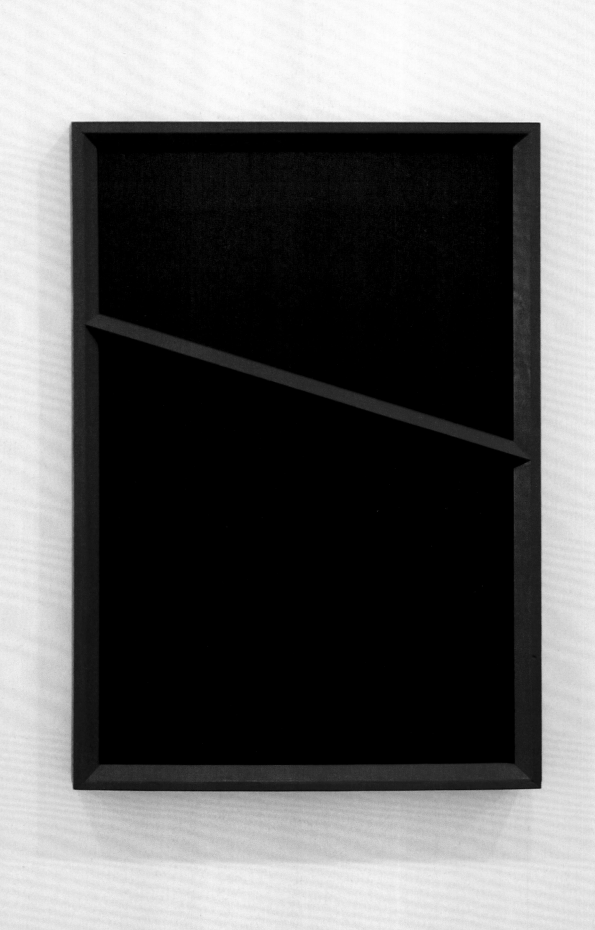

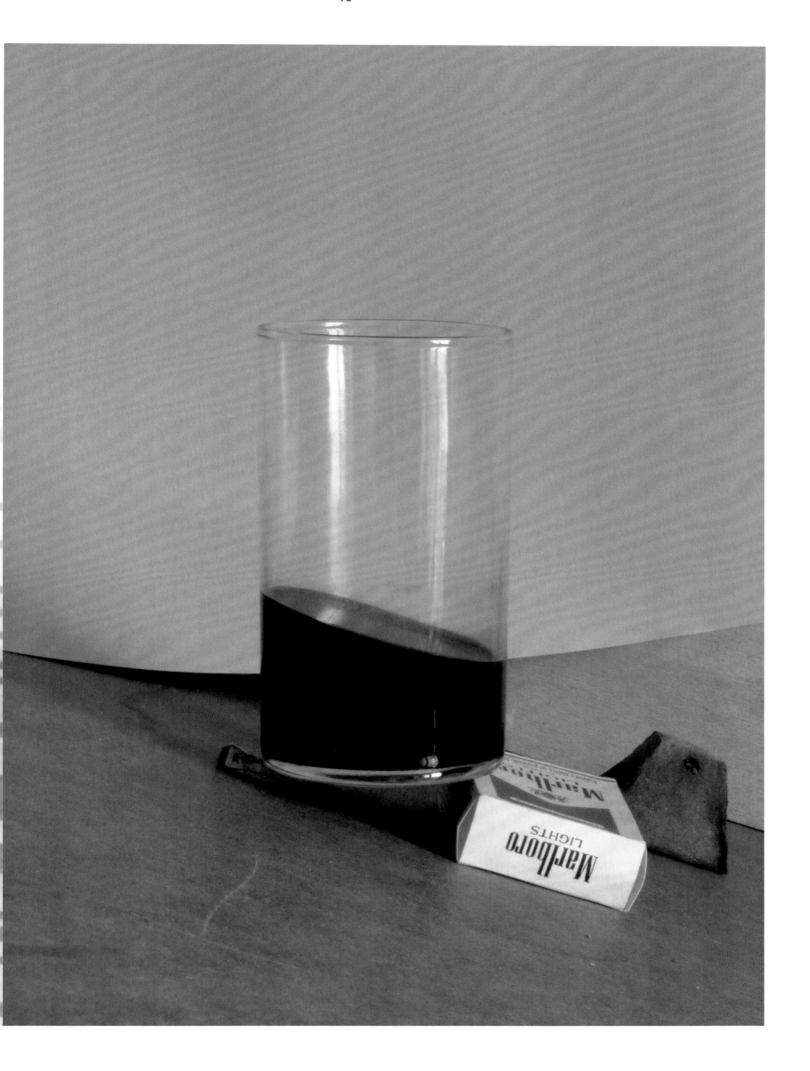

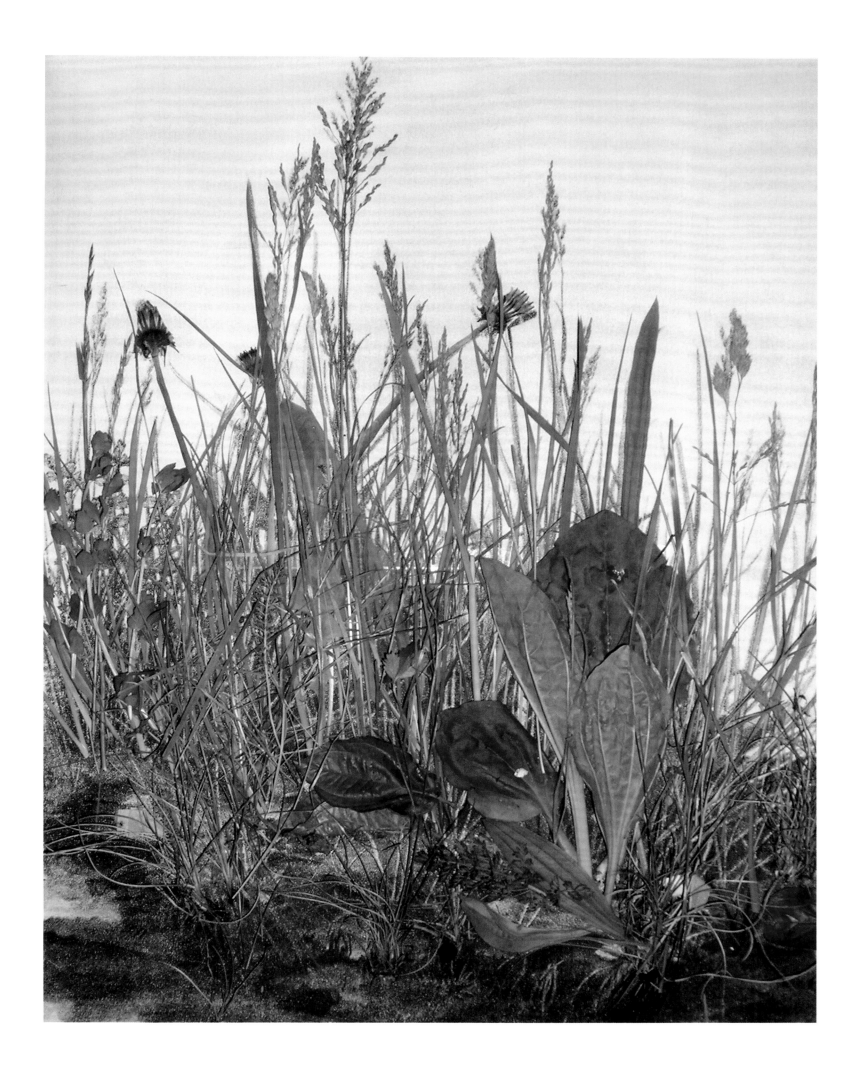

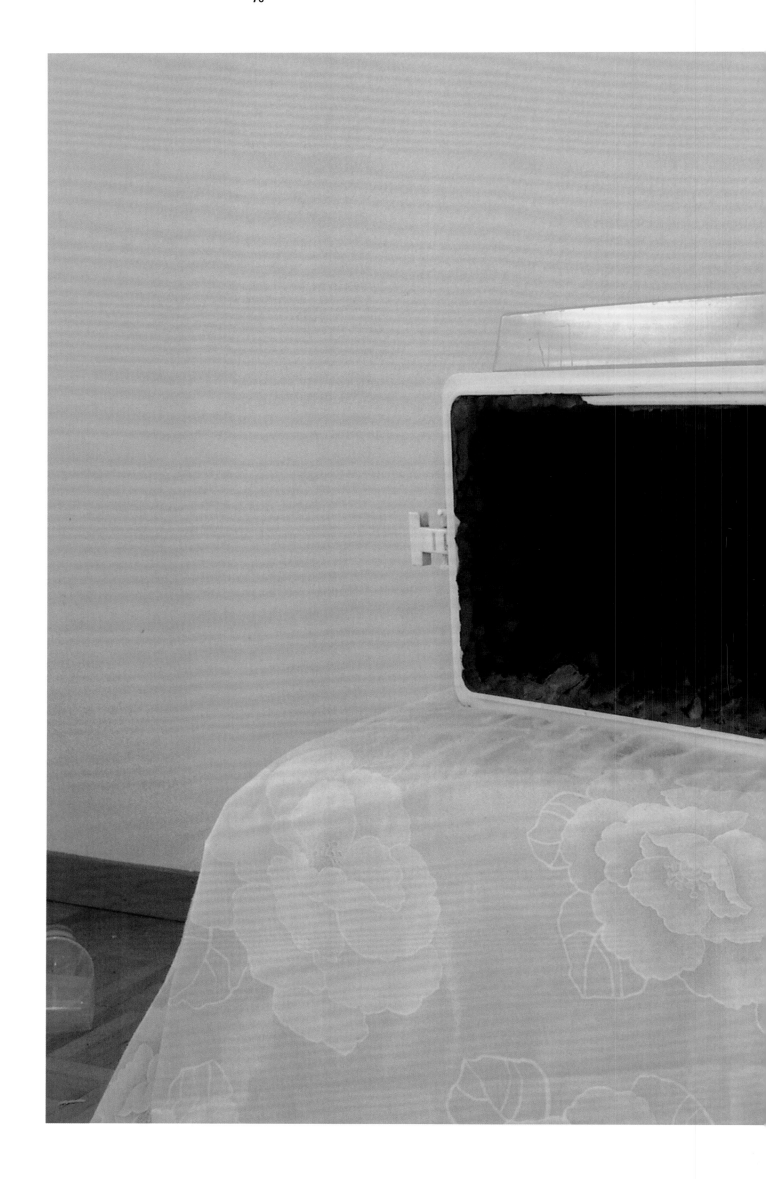

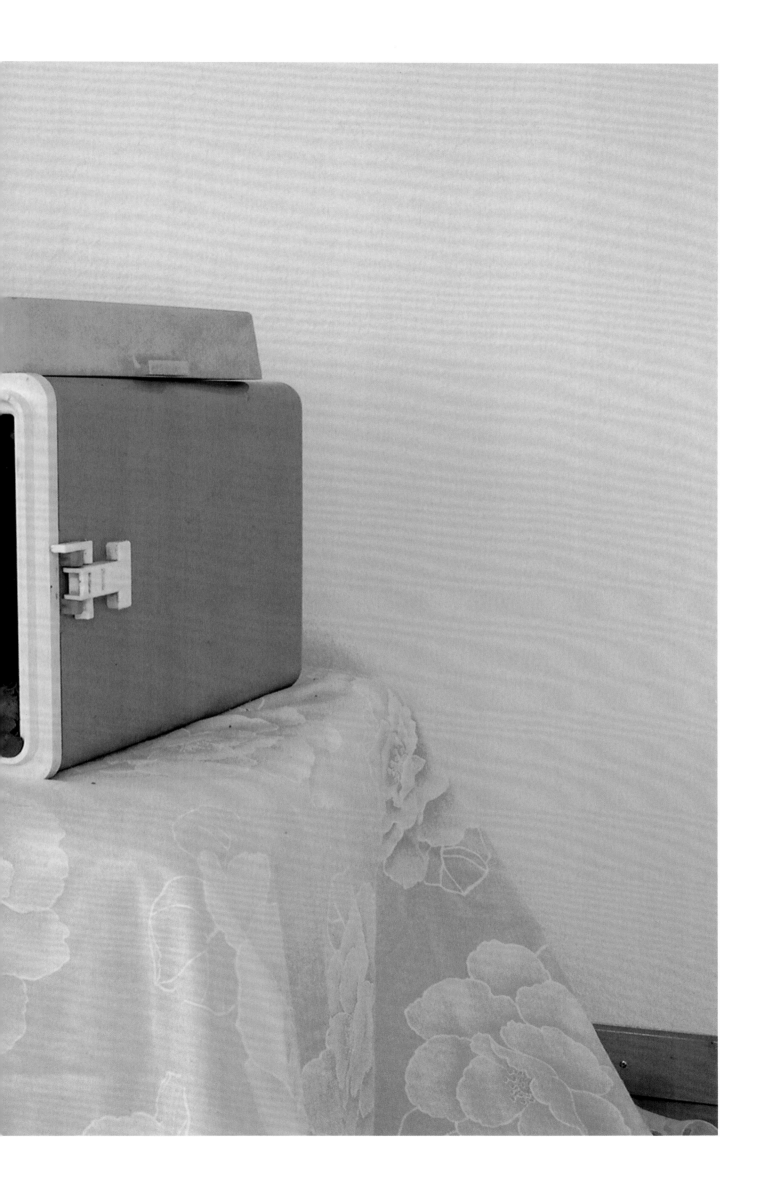

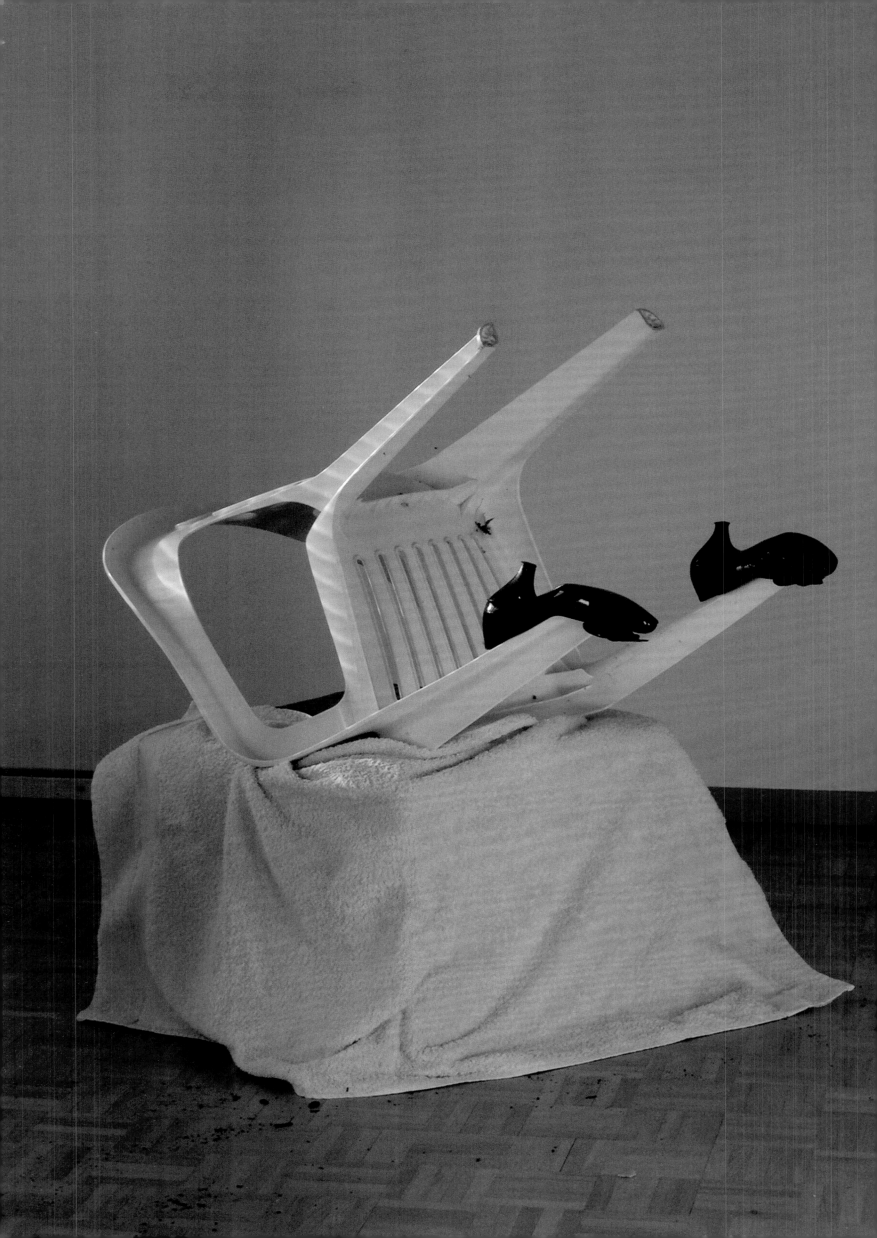

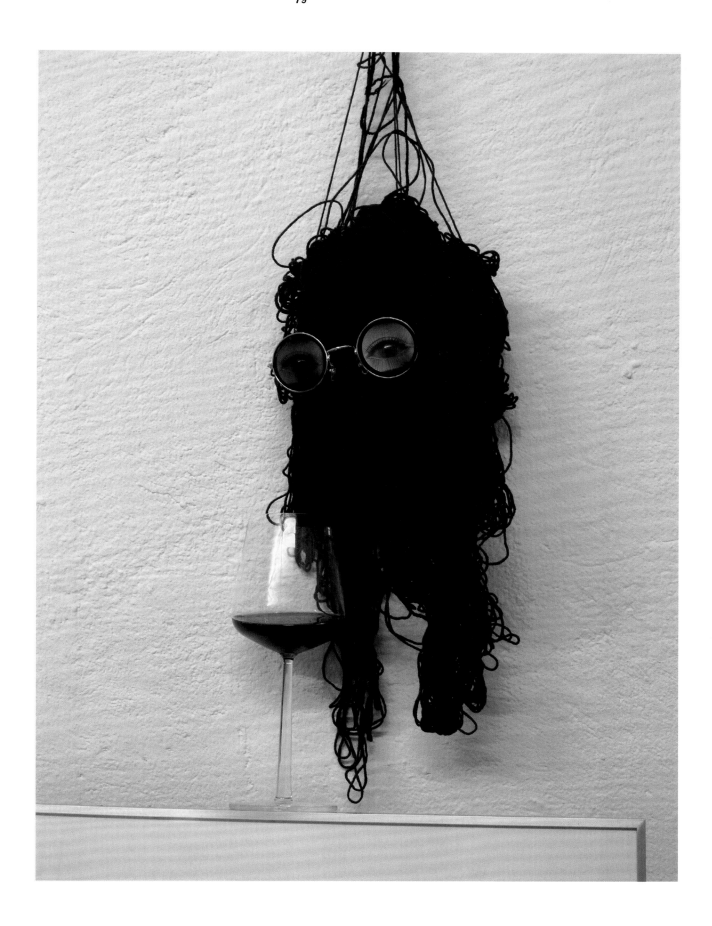

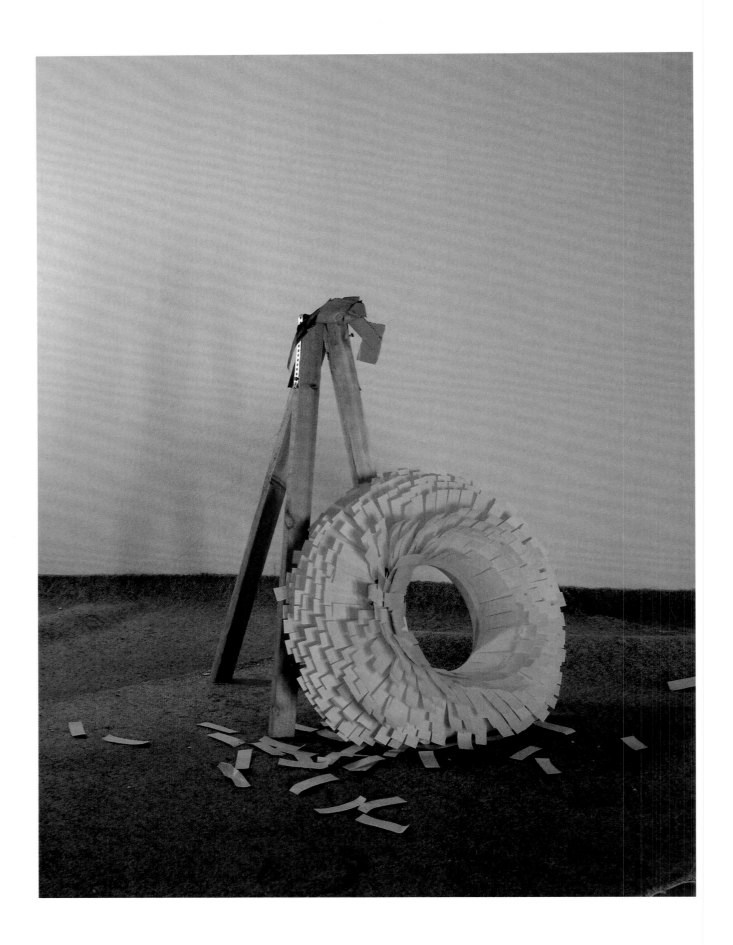

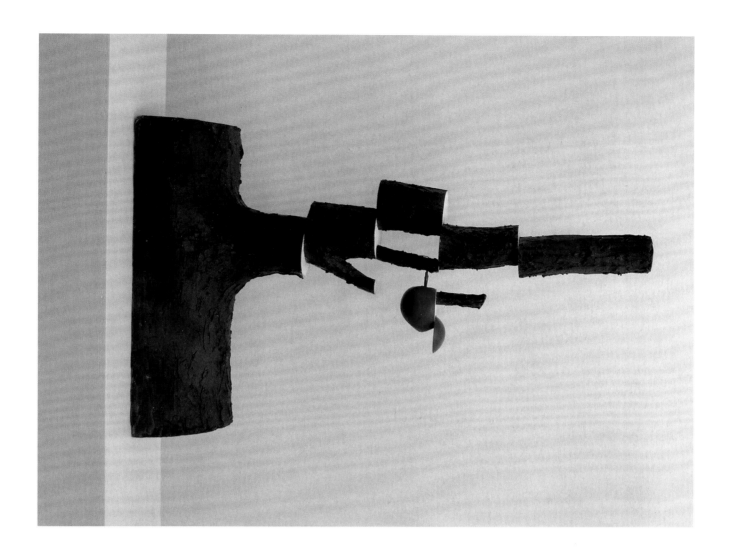

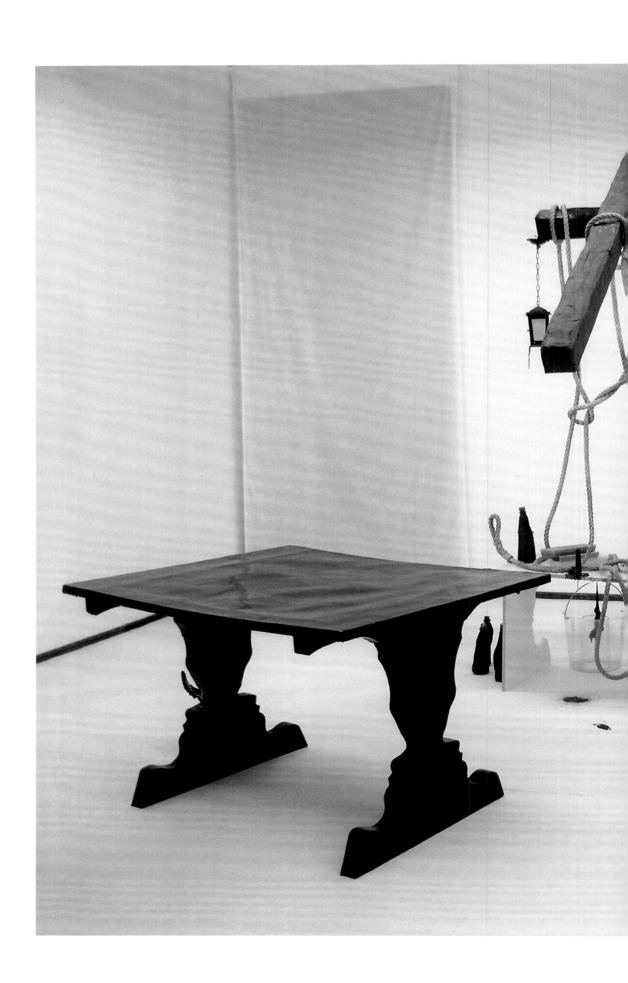

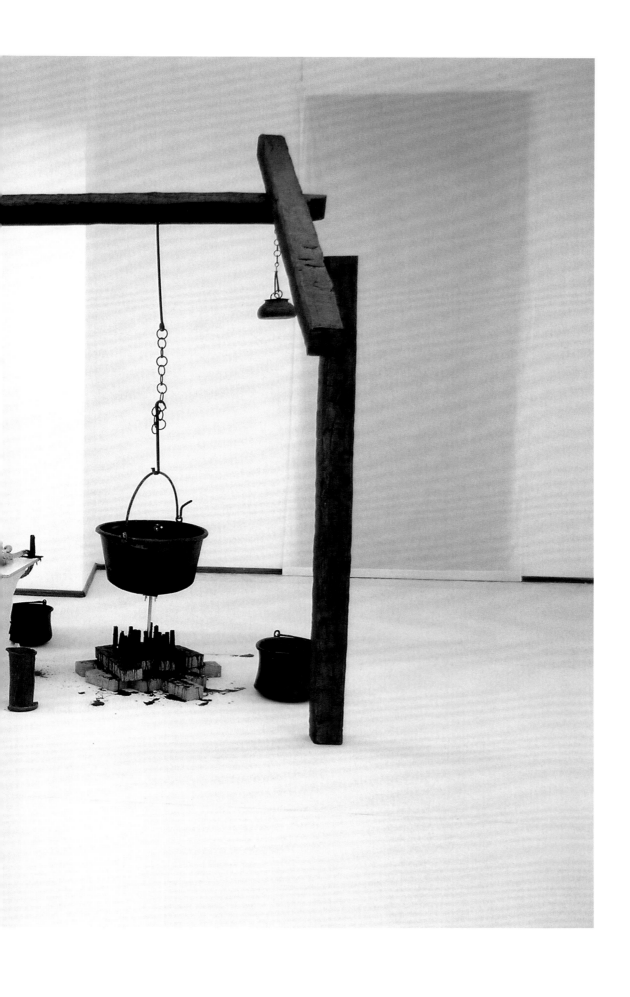

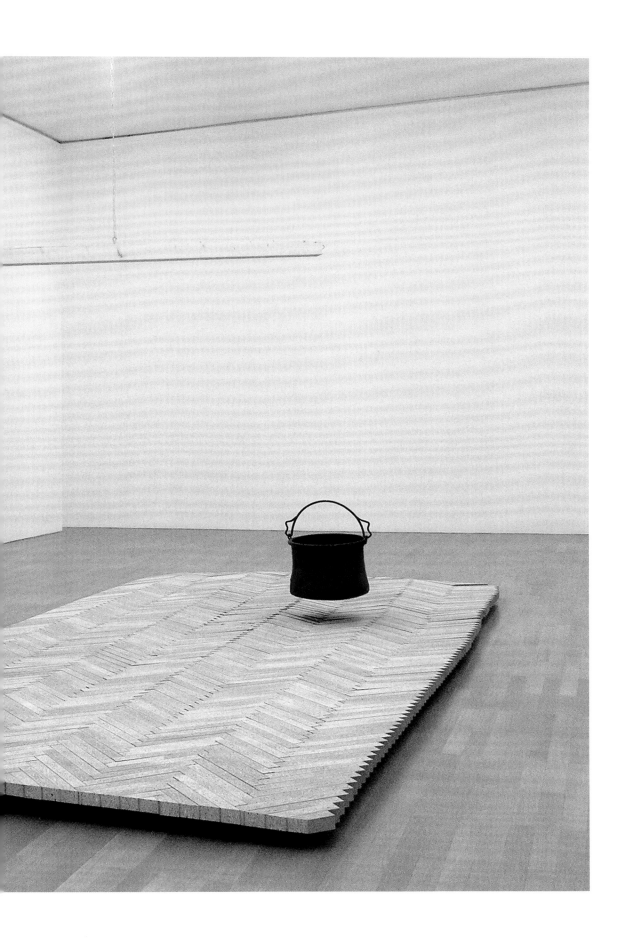

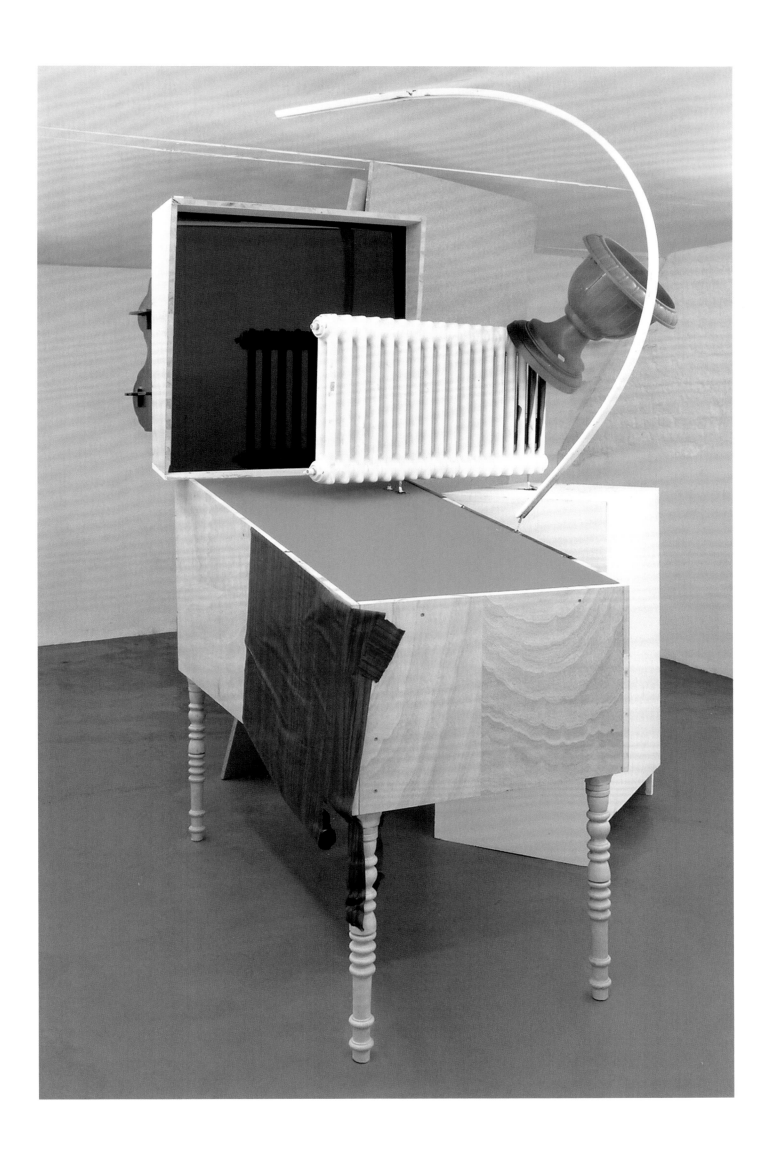

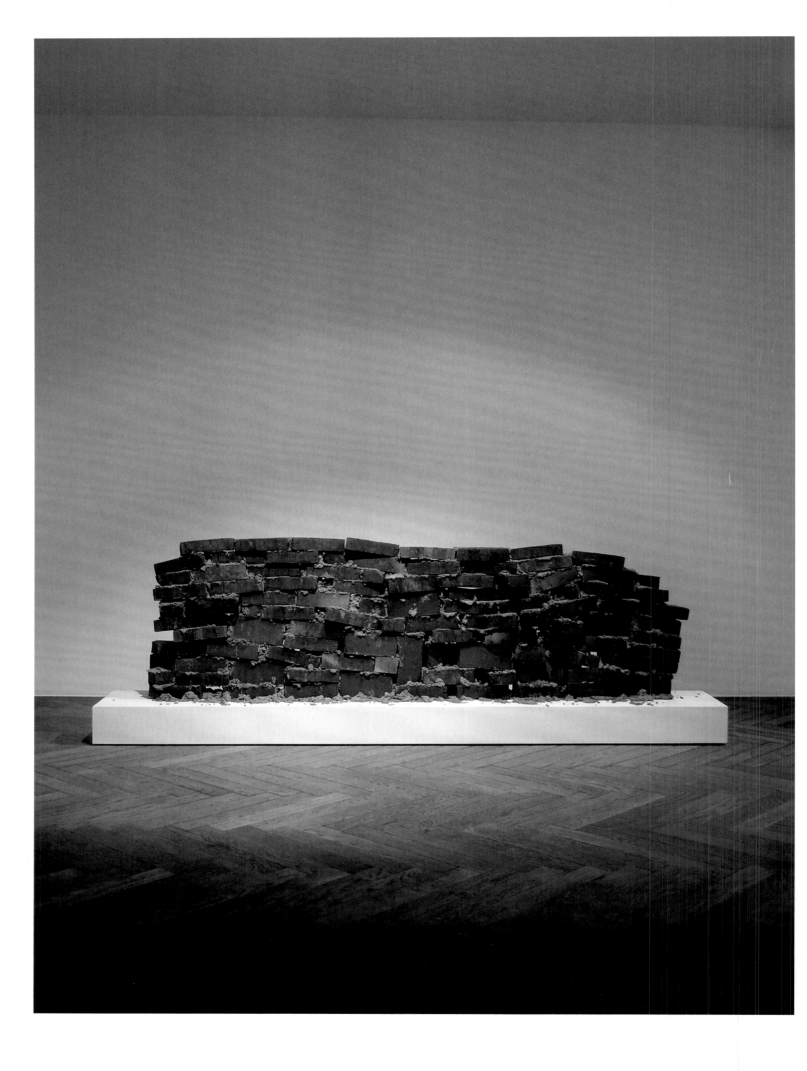

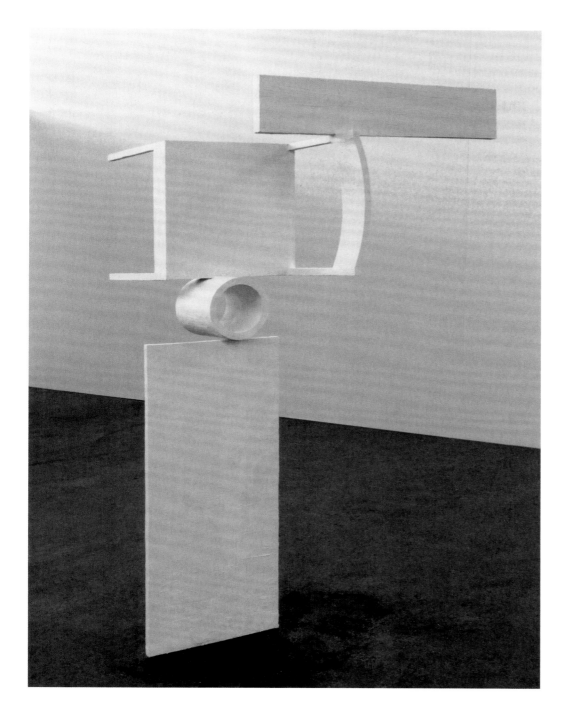
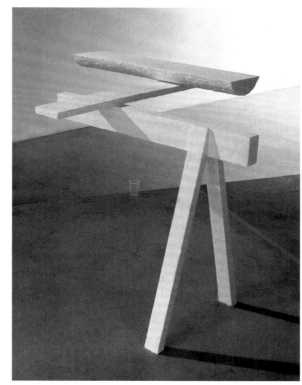

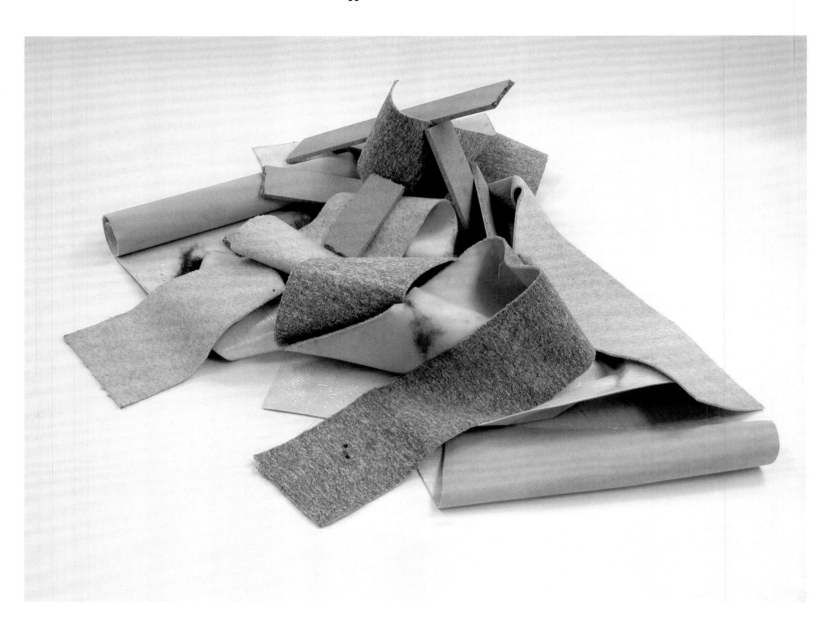
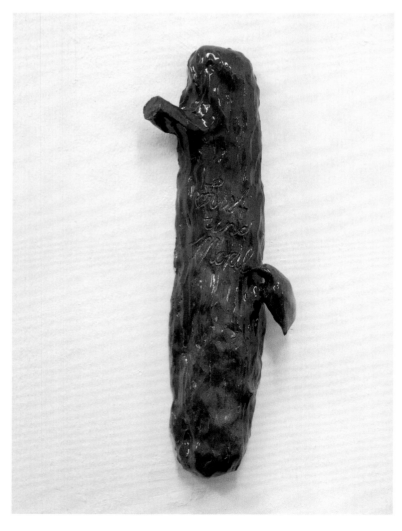

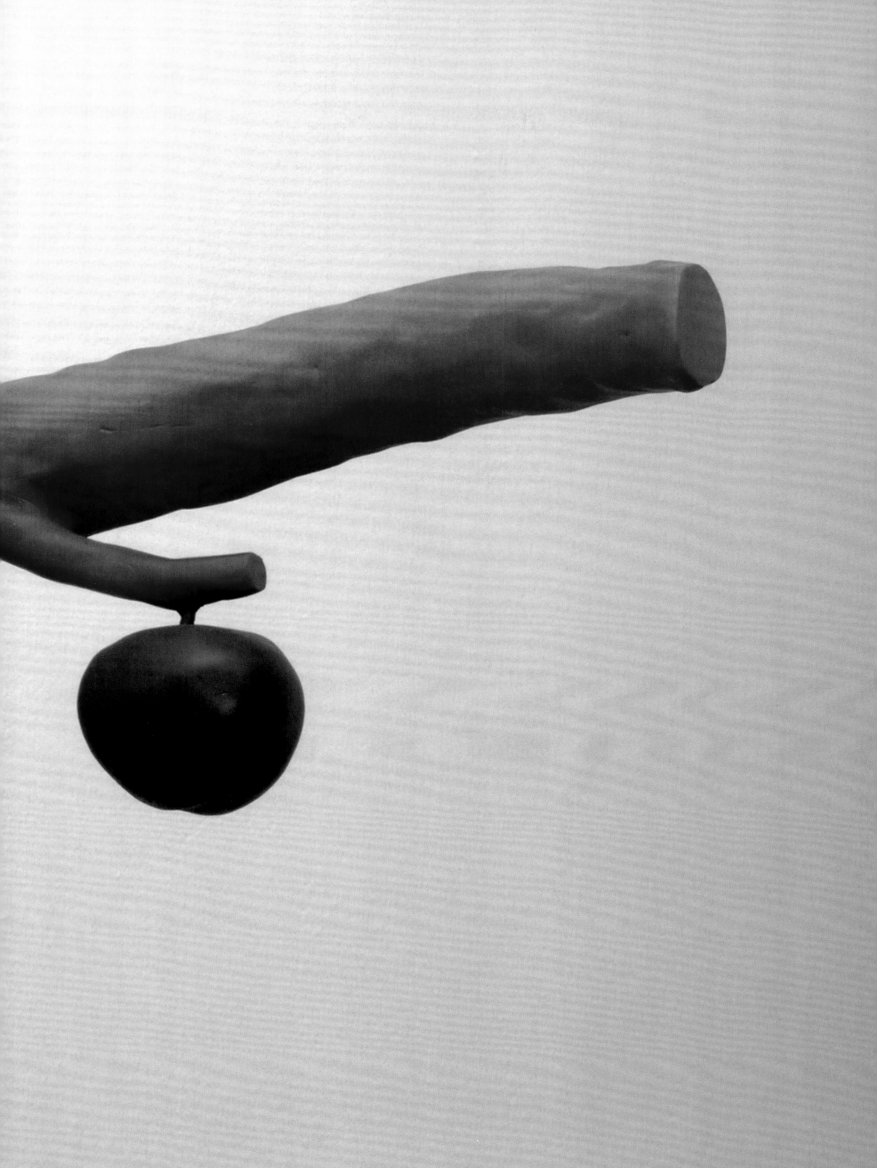

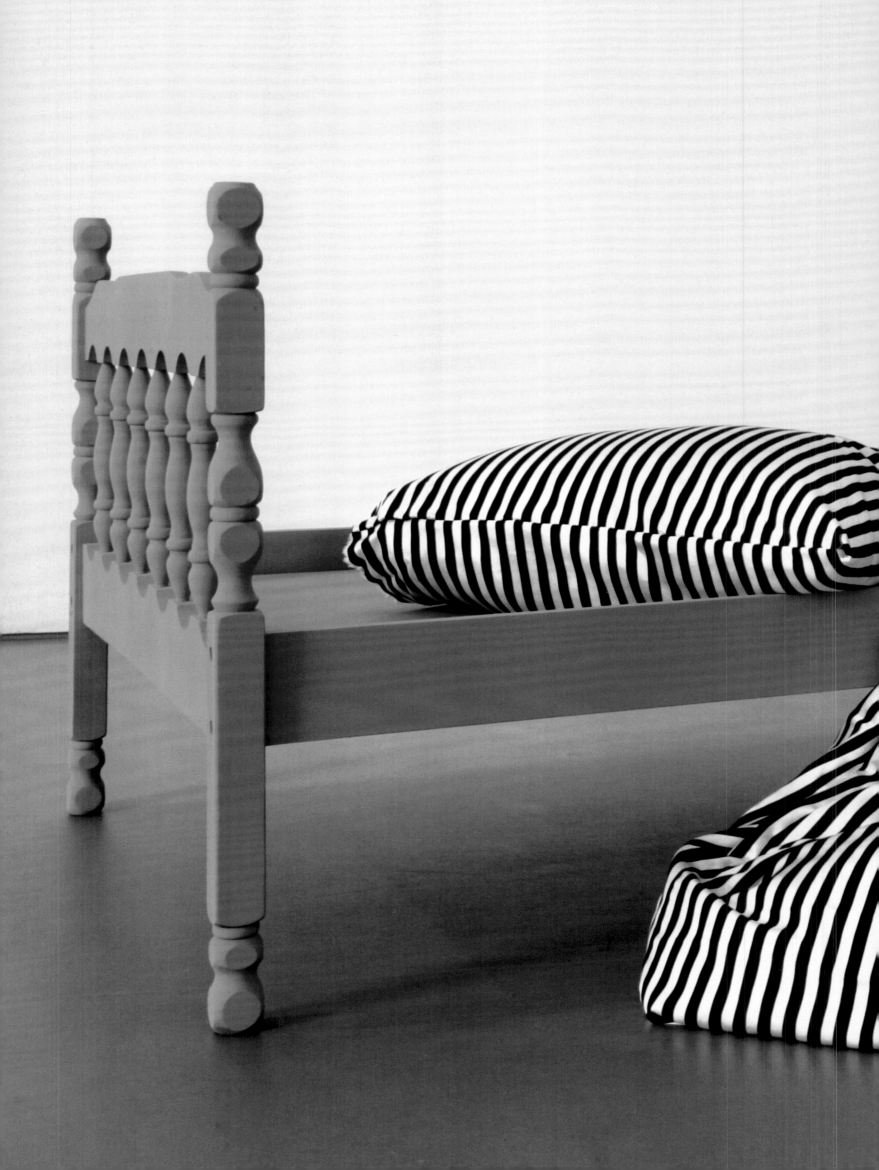

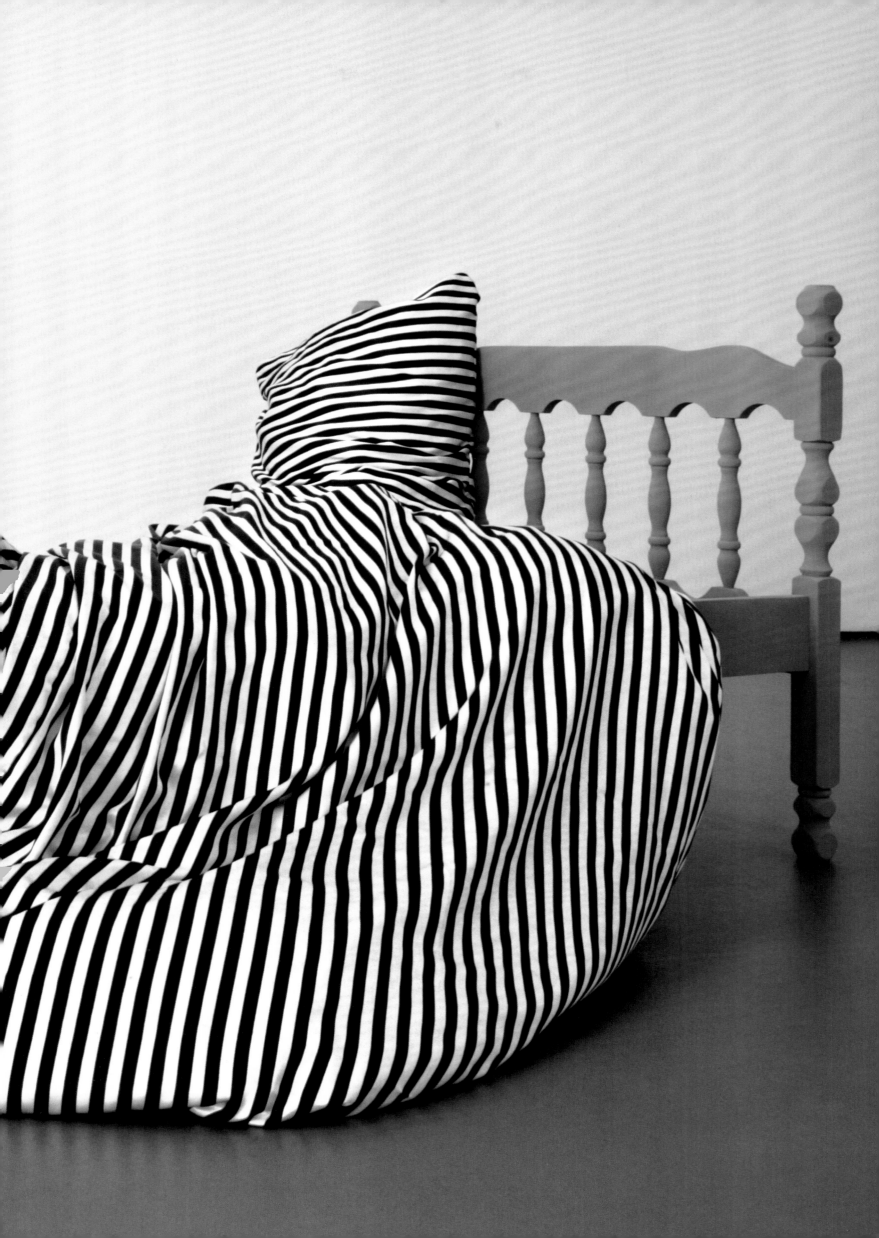

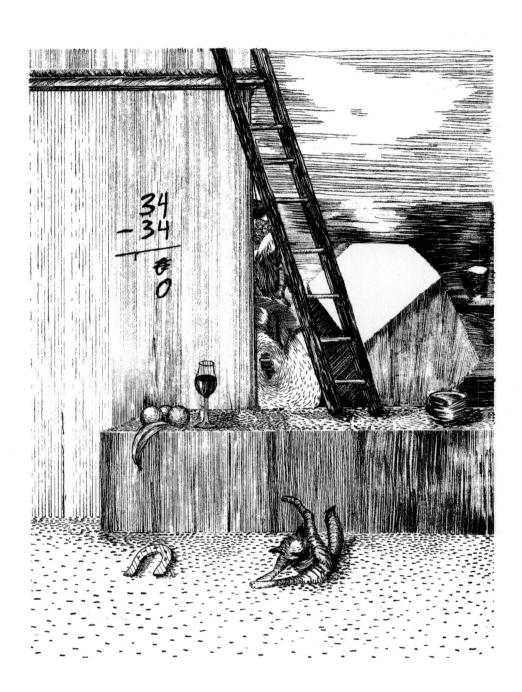

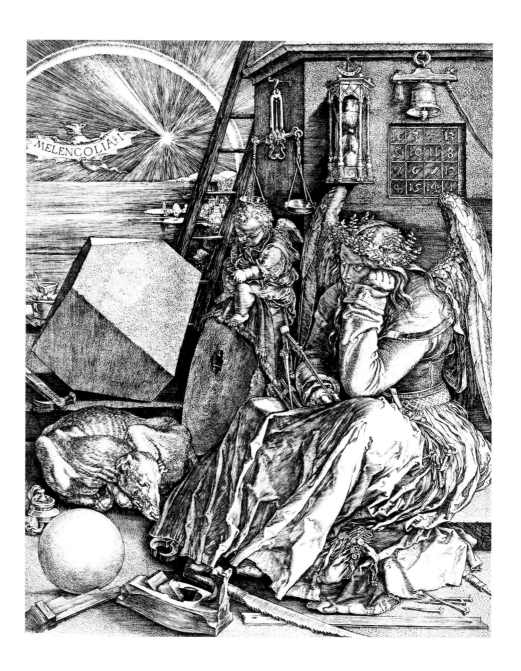

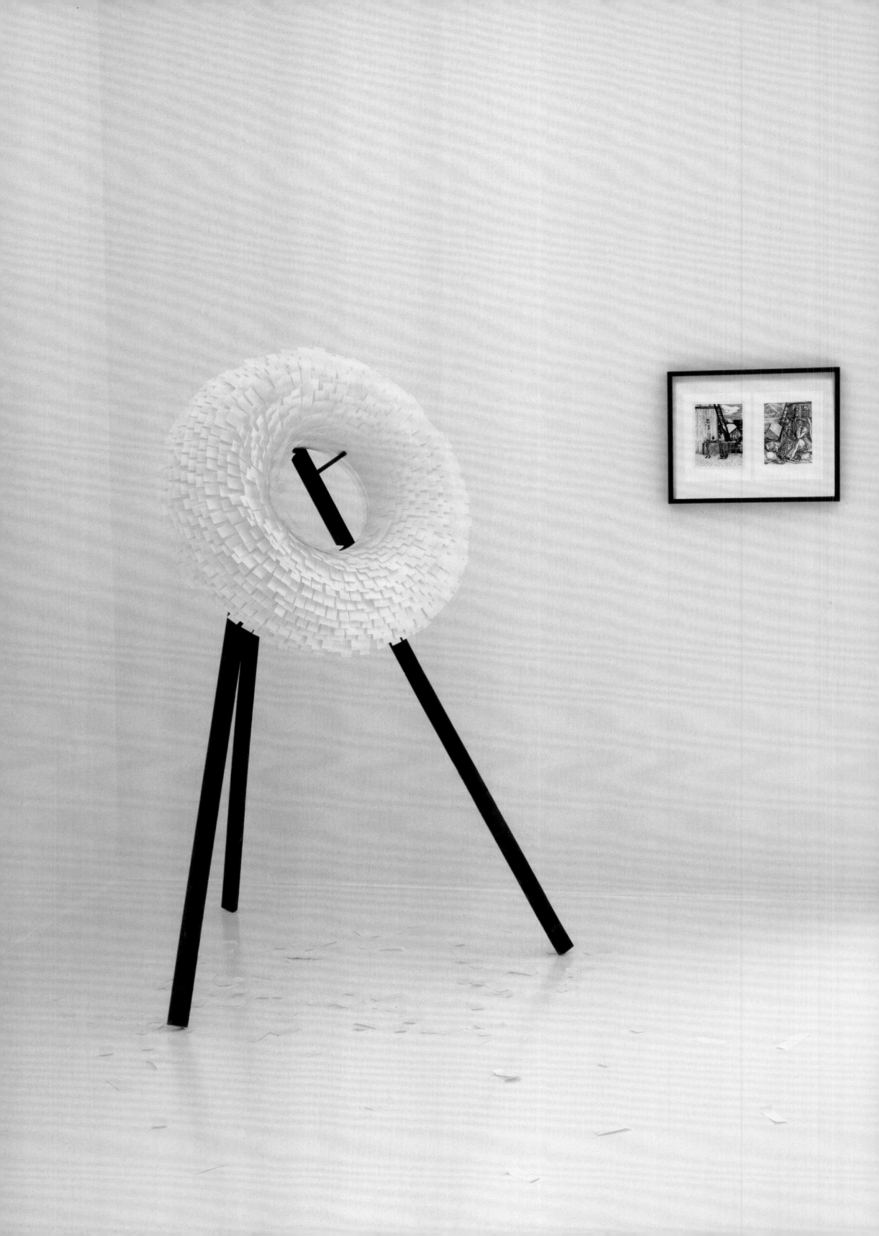

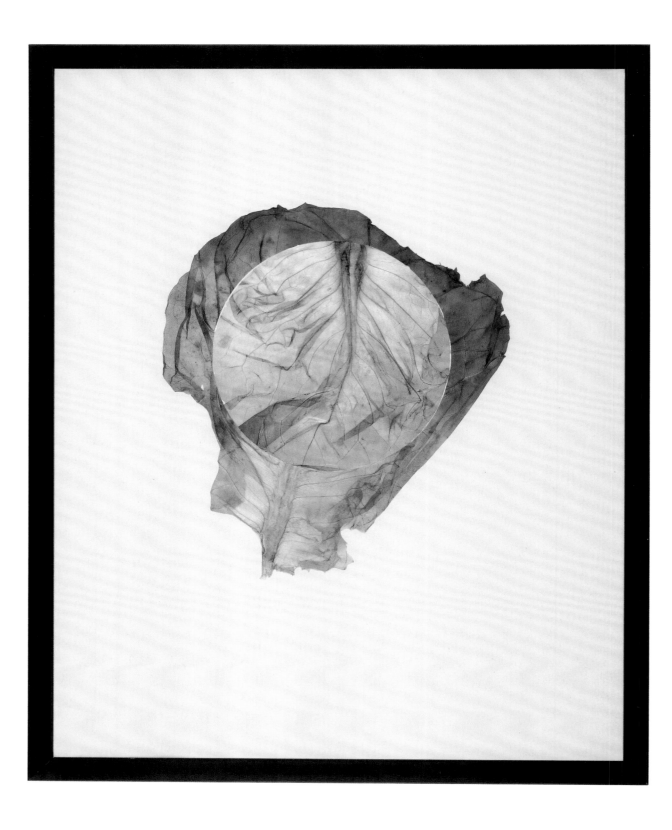

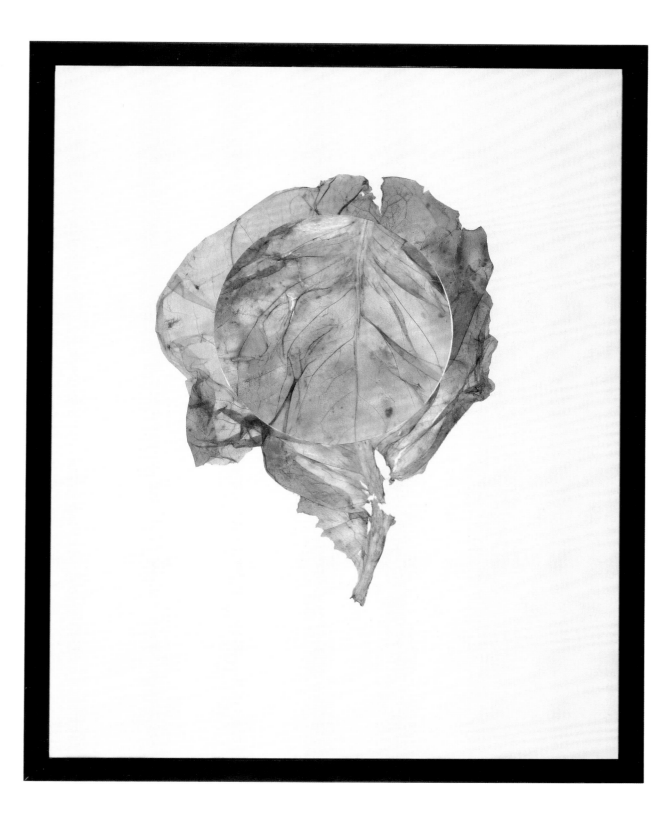

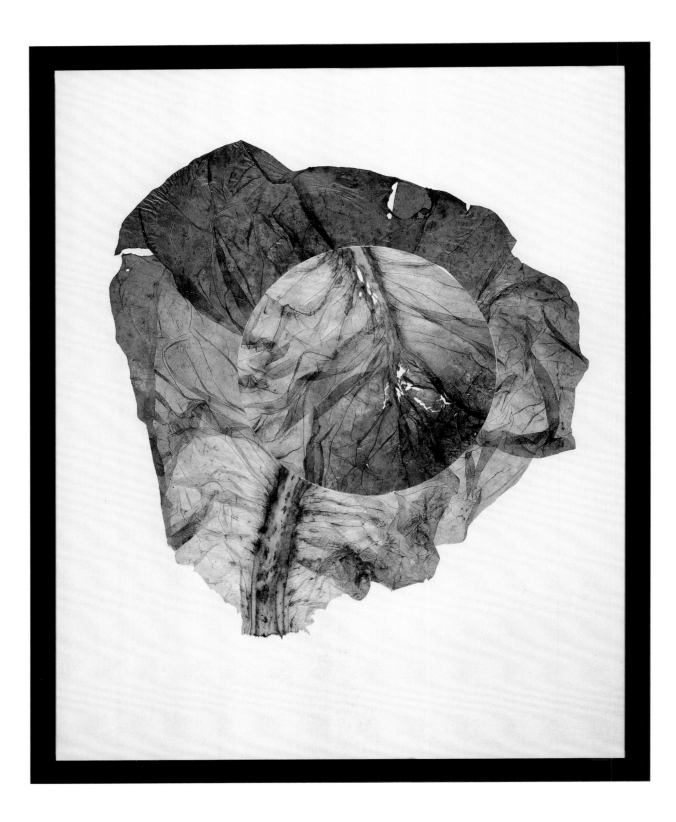

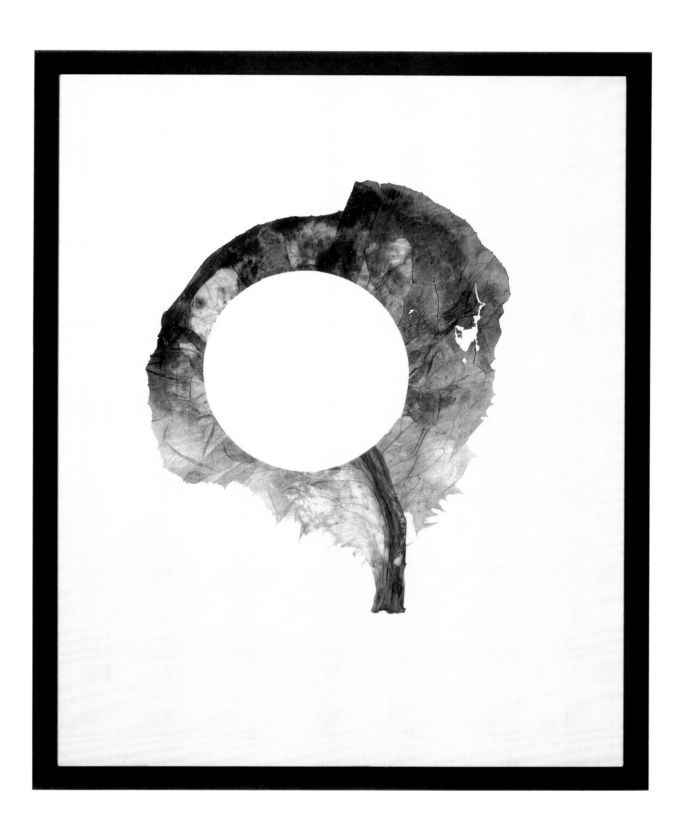

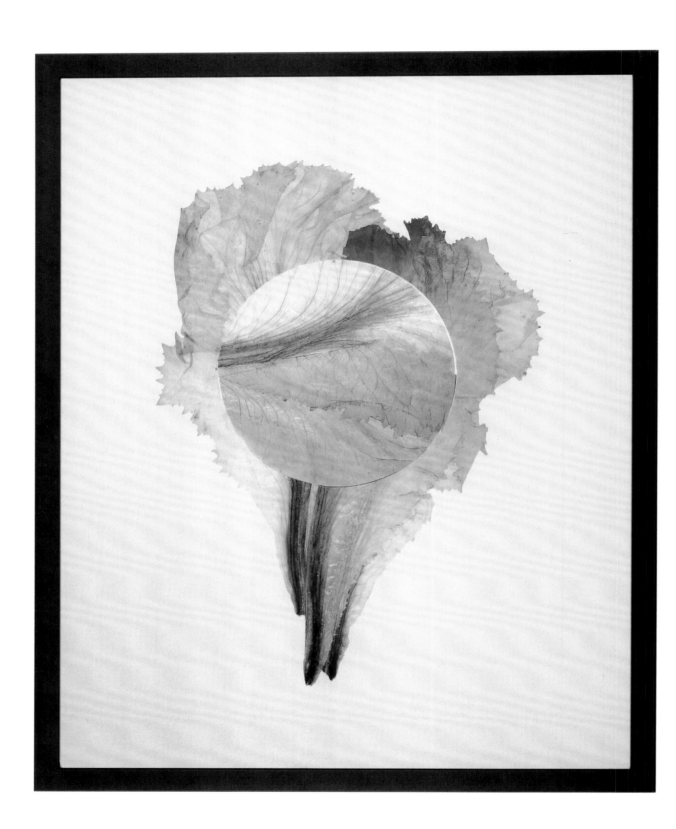

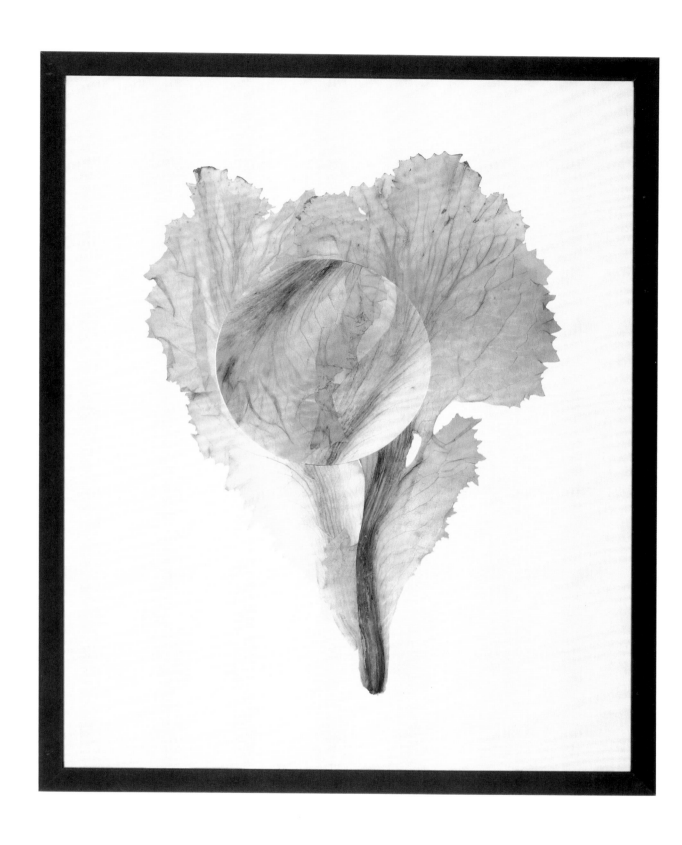

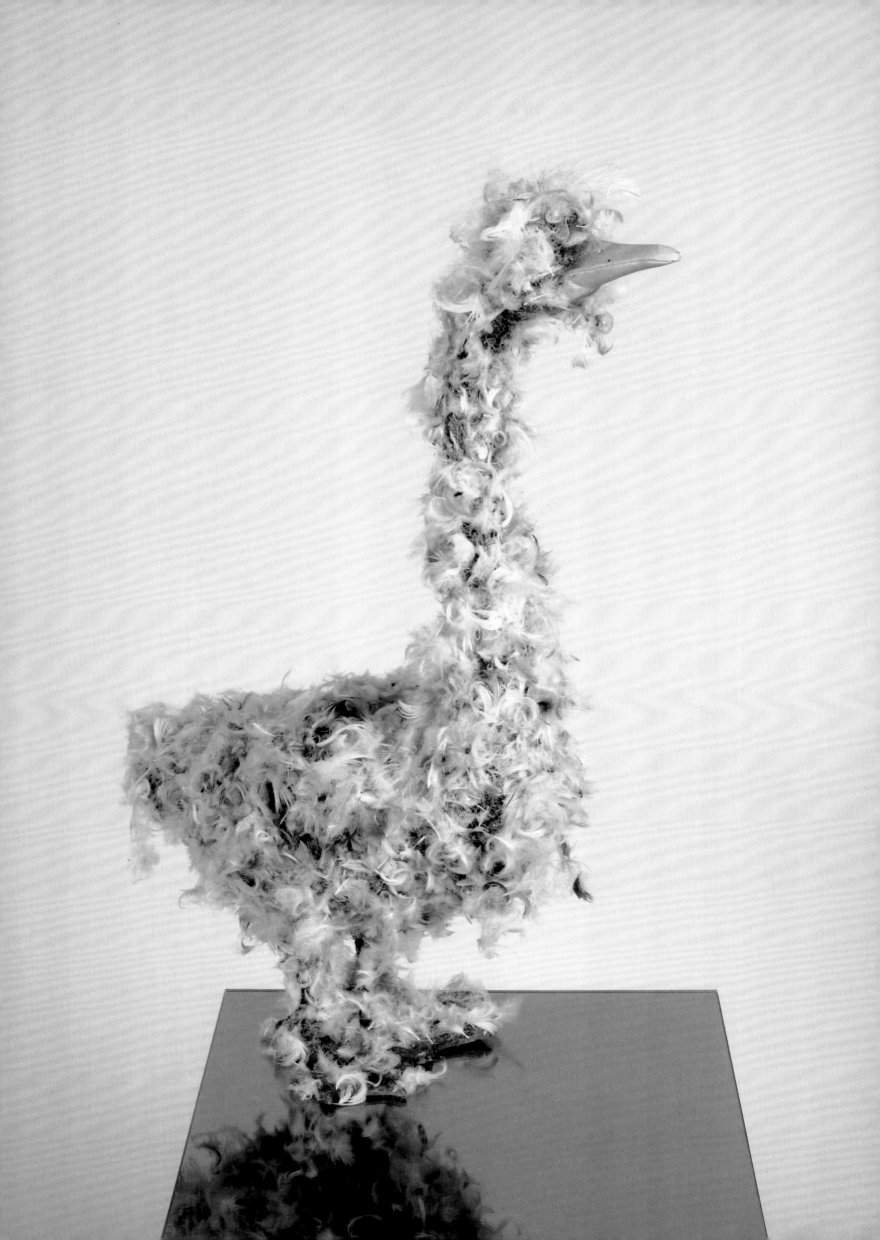

Der Wirklichkeitsscanner

Oder: Auf der Suche nach der Seele in den Dingen.
Über den künstlerischen Umgang von David Renggli mit seinen Beobachtungen.

Von Dorothea Strauss

Es ist noch leicht gesagt, David Renggli würde die Wirklichkeit scannen. Denn wenn der Schriftsteller Peter Handke von einer Rückseitenlandschaft spricht und dann diejenigen Seiten der Städte meint, die hinter den Postkartenvorderseiten liegen, könnte man bei David Renggli von einer Rückseitenwirklichkeit sprechen. So bedeutet bei Renggli der Umgang mit Wirklichkeit auch eher die Offenbarung einer wundersamen Doppelexistenz, zum Beispiel eines Wollfadens, als dass es sich bei seinen Arbeiten um eine Analyse der Kunsttauglichkeit von Alltagsgegenständen handelt. Anders gesagt: David Renggli scannt das Potenzial von Dingen und Zusammenhängen, um seltsame Geschichten zu erzählen.

Renggli ist in einem permanenten Zustand der Beobachtung seines Lebensraums, seines privaten Umfelds. Diese Beobachtung folgt keinem direkten theoretischen Anliegen, sondern versucht eher derart dünnhäutig für die Wirkungsfähigkeit von Dingen des Alltags oder auch der Kunstgeschichte zu bleiben und diese in Szene zu setzen, dass sich fast immer ein Zustand einer surrealen Wirklichkeit einstellt; eine zuvor noch leblose Wirklichkeit lädt Renggli auf mit einer Anima.

David Rengglis Aufnahmemodus scheint dabei nie auf «standby» zu stehen, und nichts und kein Ding ist ihm zu gewöhnlich, als dass er es nicht auf seine Möglichkeit hin betrachtet, diesem Ding zu einer ganz besonderen Position zu verhelfen. Verschiedenfarbige Wollfäden rahmen schrumpfköpfig dreinblickende Gesichter und vereinen sich zu einer Voodoogruppe. Renggli hatte ihre Gesichter zuvor in einen Klumpen Lehm hineingekratzt und diese Form dann mit Kunststoff ausgegossen; krude Masken, die trotz ihrer rüden Machart ein verträumtes Wesen vermitteln. So auch der Kunstlederhandschuh, der in einem melancholischen Gemütszustand zu sein scheint, während er gerade einen Brief schreibt. Der Handschuh steckt dabei in einem zusammengeschrumpelten Maschinenstrickpulli, hält einen Stift und schreibt auf ein Blatt Papier: «Du bist sch…», den Anfang eines Satzes, von dem man nur erahnen kann, wie er weitergehen könnte. Dass der Hand-

The Reality Scanner

Or: In search of the soul in objects.
Regarding David Renggli's artistic interaction with his observations.

By Dorothea Strauss

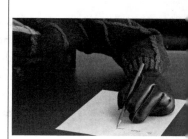

One might very easily say that David Renggli scans reality. For just as the author Peter Handke speaks of a flipside landscape, meaning those aspects of a city which lie behind the image on the front side of a postcard, in David Renggli's case, one could speak of a flipside reality. With Renggli's work, interaction with reality means the revelation of a wondrous double existence (of a strand of wool, for instance) rather than an analysis of the suitability of everyday objects for inclusion in art. In other words, David Renggli scans the potential of objects and interrelationships in order to tell strange stories.

Renggli is permanently in a state of observing his living space, his personal surroundings. This observation does not follow any direct theoretical agenda, but rather attempts to remain sensitive to the effectiveness of everyday things, and also of art history, and to focus on this effectiveness in a way which almost always defines a state of surreal reality; Renggli charges a previously lifeless reality with an anima.

All the while, David Renggli's recording mode appears never to be on standby, and no object, nothing at all is too commonplace for him to observe without considering his possibilities of being able to give this object a very special status. Differently coloured strands of wool surround shrunken, penetratingly gazing faces, and unite to form a voodoo ensemble. Renggli first scratched their faces into a lump of clay, then poured plastic into the form to produce crude masks, which despite the rough manner in which they were worked on, convey a dreamy character. The same applies to the artificial leather glove, which appears to be in a melancholy state of mind, while it writes a letter. The glove sticks out of a crumpled machine-knitted pullover, holds a pen, and writes on a sheet of paper: "Du bist sch…", the beginning of a sentence, on which one can only speculate as to how it might continue. The fact that

schuh dabei aussieht wie eine Handprothese, wie man sie noch bis in die 1970er Jahre öfters sah, verleiht der ganzen Situation eine tragisch-komische Aura. Dennoch: Renggli gelingt es in all seinen Inszenierungen, seine Protagonisten nie der Lächerlichkeit preiszugeben.

David Rengglis Arbeiten sind kein gezielter Kommentar auf unsere Wegwerf- und Konsumgesellschaft, auch üben sie keine direkte Kritik an Simulationsprozessen. Aber sie lösen eine philosophisch geprägte Beschäftigung mit der Eigenheit der Wirklichkeit unserer Gegenstandswelt aus. Dabei stehen Rengglis Arbeiten in direktem Bezug zu den Auseinandersetzungen mit post-popkulturellen Analysen, denn sie sind ohne die Einbeziehung der Alltags- und Popkultur in die Kunst seit den 1960er Jahren nicht denkbar. Gleichzeitig erscheinen sie ausgesprochen unverfälscht, häufig auch entwaffnend arglos. Mit beinahe naiver Geste beschwören sie immer wieder eine Märchen- und Geisterwelt in einer postindustriellen Gesellschaft herauf, die sich wieder nach Fetischen sehnt. David Renggli verwendet die Dinge des Alltags, um in jedem noch so banalen Etwas eine entrückte Seele zu inszenieren.

Zurück zur Rückseitenwirklichkeit. Bis heute gibt der im Jahre 1514 entstandene Kupferstich «Melancholie» von Albrecht Dürer der Kunst- und Kulturwissenschaft Rätsel auf. Die Interpretationen darüber, was die abgebildeten Dinge und Wesen in diesem mystisch anmutenden Stich bedeuten, sind vielfältig. David Renggli hat den Kontext der Szene weiterentwickelt, zeigt, was sich hinter dem Schauplatz aus entgegengesetzter Blickrichtung ereignet. In einer zweiten Zeichnung – in der Manier dem Kupferstich ähnlich und in gleichem Format –, die er links neben der Reproduktion der «Melancholie» präsentiert, hat er ein fast alltägliches Setting inszeniert: Unter dem Titel «Melancholie von Hinten und von Vorne» zeigt er uns nämlich, was sich hinter der quaderähnlichen Architektur abspielt, vor der die personifizierte Melancholie in sinnierender Körperhaltung sitzt. Renggli vertauscht die Schauplätze: Nun sehen wir den Quader und die Leiter von hinten, und auch der Himmel scheint derselbe. Auf einem Mäuerchen steht ein halb gefülltes Glas Rotwein, Früchte liegen daneben, ein Katze putzt sich das Fell, und auf der Wand steht als Subtraktion gekritzelt «34 minus 34 ergibt 0». Die schlichte Rechnung zitiert das magische Quadrat von der Vorderseite des Quaders, dessen Zahlen immer 34 ergeben. Hier, in der Rückseitenwirklichkeit, sind die rätselhaften Zeit- und Raumeinheiten der Vorderseite wieder auf null gestellt.

the glove looks like an artificial hand, of which many were still to be seen up until the 1970s, lends the whole situation a tragic-comic aura. Nevertheless, in all of his constructed scenes, Renggli manages to avoid ever surrendering his protagonists to ridicule.

David Renggli's work is not a specific commentary on our throw-away/consumer society, and it does not directly criticise processes of simulation. However, it triggers a philosophically charged preoccupation with the peculiarity of the reality of our world of objects. At the same time, Renggli's work is directly linked to the debates on post-pop-cultural analyses because it would be inconceivable without the incorporation of everyday culture and of pop culture into art, which has been taking place since the 1960s. Simultaneously, it appears remarkably unadulterated, and often disarmingly ingenuous. With an almost naive gesture, it repeatedly evokes a world of fairy tales and ghosts in a post-industrial society which once again yearns for fetishes. David Renggli uses everyday items in order to depict an enraptured soul in every "something", no matter how banal.

Back to the flipside of reality: to this day, the copper engraving "Melencolia" by Albrecht Dürer, created in 1514, poses a puzzle for art historians and cultural scholars. The interpretations of what the objects and beings depicted in this mystical-looking engraving might mean, are manifold. David Renggli has developed the context of the scene further, and shows what occurs behind the scenes, from the opposing perspective. In a second drawing (in a similar style to the copper engraving, and in the same format) which he presents to the left of a reproduction of "Melencolia", he has created an almost everyday setting: under the title "Melancholie von Hinten und von Vorne" ("Melencolia from Behind and from the Front"), he shows us what is taking place behind the cuboid architecture, which the personified melancholy sits in front of with a reflective posture. Renggli swaps the settings: now, we see the cuboid and the ladder from behind, and the sky also appears to be the same. A half-filled glass of red wine stands on a low wall, fruit lies beside it, a cat cleans its fur, and the subtraction "34 minus 34 equals 0" is scrawled on the wall. This simple calculation cites the magic square from the front side of the cuboid, the numbers of which always amount to 34.

In dieser Arbeit mystifiziert Renggli nicht wie in anderen Werken eine alltägliche Realität, sondern profanisiert sozusagen die geheimnisvolle Szene. Dem mystischen Gleichnis haucht er den Odem des normalen Lebens ein, und die engelsgleiche Melancholie darf sich zwischendurch vom Posen auch mal bei einem Gläschen Wein ausruhen.

«Melancholie von Hinten und von Vorne» zeigt exemplarisch ein wesentliches Moment im Werk von David Renggli: Anmutungsqualitäten von Materialien und Sinnzusammenhänge, allgemein gültige Vorstellungen und Klischees macht er sich zunutze und entwickelt neue Assoziationsräume, aus denen heraus auch neue Geschichten entstehen.

Here, in the flipside reality, the puzzling units of time and space from the front side are set back to zero.

In this work, Renggli does not mystify an everyday reality like in other works, but instead he lends a kind of profanity to the mysterious scene. He breathes normal life into the mystical allegory, and the angelic melancholy is also allowed to take an occasional break from posing and relax with a glass of wine.

"Melancholie von Hinten und von Vorne" is a prime example of an essential moment in the work of David Renggli: he uses the evocative qualities of materials and sensory associations, universal perceptions and clichés, to develop new associative spaces, from which new stories also emerge.

Helm von hinten

Die Grauzonen der Wahrnehmung im Werk von David Renggli

Von Christoph Doswald

Die Abstrahierung alltäglicher Verrichtungen schreitet voran. Unmittelbarkeit als integraler Teil der Wahrnehmung verliert zusehends an Bedeutung. Und beide Entwicklungsstränge haben zur Folge, dass sich in der abendländischen Gesellschaft eine immer paradoxere Lebenswirklichkeit herausbildet. Dieser Kontext bildet den grösseren Hintergrund des Werks von David Renggli (*1974), der diese neuen gesellschaftlichen Konventionen mit lapidarem Humor und nonchalantem Wortwitz kommentiert. «Hommage an die Interpretation der Zeit» lautet der Titel einer Installation, die den Schweizer Künstler vermeintlich direkt auf den Campus aktueller Diskurse zu befördern scheint. Doch bei Renggli bleibt vieles Rhetorik. Die Anspielungen an die grossen Fragen erscheinen wie eine vom Ennui des materiell und kulturell Gesättigten, ja Saturierten getragene Attitüde. Und gerade diese im Zusammenspiel mit stupender formaler Bildhaftigkeit vorgetragenen Spielereien locken in ein paradoxales Labyrinth voller Bezüge und Referenzen – die doch alle ohne Folge bleiben.

Nehmen wir etwa den schwarzen Raum, mit «The Night it Became Suddenly Bright Again» betitelt, aus einer ganzen Serie von ähnlichen Werken. Die Installation versammelt eine Reihe von Objekten, wie sie in Werkstätten und Wohnräumen vorzufinden sind: Stühle, Sofa, Tisch, Regale, Krüge und einiges anderes mehr an häuslichem Mobiliar. Wie in einer Abstellkammer, die mit Dingen angefüllt ist, die eigentlich im Leben ihrer Besitzer keine wesentliche Rolle mehr spielen, versammelt sich in der Installation ein stilisiertes Leben aus Relikten, quasi ein Stillleben des Alltäglichen, und eine Ansammlung von kunsthistorisch Aufgeladenem, etwa ein Spinnrad. Irritierend in dieser Kulisse ist auch die Präsenz einer Säge, eines Werkzeugs, das zwar in keiner ambitionierten Heimwerker-Werkstatt fehlen darf, in einer Abstellkammer aber ein ungewöhnliches Utensil ist. Zumal mit der Säge offenbar eben erst gearbeitet worden ist – davon zeugen einige Holzabschnitte, Dachlatten und Sägemehl. Der gesamte Raum ist in schwarze Farbe getaucht, die Oberflächen gepudert vom Sägemehl, einerseits Restanz des Heimwerkertums andererseits subtil-verträumte Sandmann-Lichtspur. Zu diesem Ambiente kann man als Betrachter

Helmet from Behind

The grey areas of perception in the work of David Renggli

By Christoph Doswald

Everyday routines are acquiring progressively more abstract proportions. Immediacy as an integral part of perception is losing more and more of its significance. The consequence of both these development strands in Western society is the emergence of an increasingly paradoxical lifestyle. This is the wider background of the work of David Renggli (born in 1974), who comments on these new social conventions with a casual sense of humour and a nonchalant pun: "Homage to the Interpretation of Time" is the title of an installation which appears to transport the Swiss artist directly into the arena of topical discourse. Yet many things remain rhetorical with Renggli. His allusions to big questions seem like an attitude of ennui of someone who is materially and culturally replete and indeed saturated. But it is precisely these playful elements, presented in their interaction with an amazingly formal pictorial quality, that lure us into a paradoxical maze full of citations and references which all remain inconsequential.

Take for instance his black space entitled "The Night it Became Suddenly Bright Again" from an entire series of similar works. This installation comprises a range of objects that can be found in workshops and living rooms: chairs, a sofa, a table, shelves, jugs and several other domestic items. Like a utility room full of things that have ceased to play any major roles in the life of their owner, the installation presents a stylised life full of relics – like a still life of everyday objects and a collection of items charged with art history, for instance a spinning wheel. Another irritating element on this scene is the presence of a saw: undoubtedly an essential tool in any DIY workshop, but rather an unusual appliance in a utility room – particularly because the saw was apparently used only a short while ago, as indicated by the pieces of wood, the roof timber and the sawdust. The whole room is submerged in black, each surface powdered with sawdust, bearing witness to some DIY work, yet in a lighter colour, as if it were the subtle, dream-like tell-tale signs of the sandman. This ambience prompts us

diverse Assoziationen und Theorien entwickeln. Verweist der Raum auf eine Brandkatastrophe? Ist es die nächtliche Rückzugszone eines Kleinbürgers, der des Nachts zum Sägen in den Keller steigt? Geht es in der Installation um die Auseinandersetzung mit künstlerischen Vorläufern wie Alberto Giacomettis Atelierzeichnungen oder Cézannes Stillleben? Oder handelt es sich um eine Kulisse aus einem Set für einen Horrorfilm? Muss also damit gerechnet werden, dass uns das verlassene Zimmer in einem cineastischen Kontext noch einmal begegnet?

Die Verunklärung medialer Aggregatszustände zieht sich wie ein roter Faden durch das Werk Rengglis, das quasi mit den Mitteln einer naiven Phänomenologie operiert und einen stets frischen, neugierigen Blick auf vermeintlich Abgesichertes und Etabliertes wirft. Prekär muss deswegen eine zweifelsfreie Identifikation bleiben, wenn es um Abbildungen installativer Situationen geht. Diese können, wie etwa eine geplatzte Salatschüssel («Salatlippen», 2003), in Ausnahmefällen offenkundig nur für den Moment der fotografischen Dokumentation hergerichtet worden sein, was die Beurteilung ihrer Erscheinungsform erleichtert – das faulende Grünzeug und der auslaufende Balsamico-Essig wäre eine Zumutung für jede installative Werkspräsentation. Aber diese mediale Eindeutigkeit findet sich nur bei wenigen Bildreproduktionen. Meist operiert der Künstler nämlich in der Grauzone unserer Wahrnehmung. «Die, die sich hochgeschlafen» (2005) zeigt vermeintlich eine Staffelei in einem Atelier. Sie steht vor einer weissen Wand, die dunklen Holzlatten mit Farbflecken und Spritzern gezeichnet: das Arbeitsutensil des Künstlers. Auf den zweiten Blick wird klar, dass es sich nicht wirklich um ein Malinstrument handelt, sondern um einen skulpturalen Nachbau. Und schaut man noch genauer hin, zeigt der simulierte Träger des in Entstehung befindlichen Bildes die Charakteristik eines Bildrahmens. Der Träger wird also Bild und das wiederum zur installativen Leerstelle, die nur eine dahinterliegende Wand rahmt. Und das Foto, sofern es denn eines ist, führt uns diesen Mechanismus vor Augen.

Besonders signifikant stellt Renggli solch labyrinthische Verunklärungen mit «Helm von hinten» (2002) vor. Das Bild, eine Fotografie, repräsentiert eine Installation, die aus einem Stuhl, zwei dreibeinigen Ständern (wohl ein Notenständer und ein Fotografenstativ), einem Motorradhelm, zwei Handschuhen, zwei Handspiegeln und Schraubzwingen besteht. Im Hintergrund sind braune Lounge-Hocker erkennbar, was die These von den Musikversatzstücken unterstreicht – das gesamte Mobiliar könnte aus dem Übungskeller einer Teenie-Band stammen. Es sind

to develop a variety of associations and theories. Does the room indicate some devastating fire that took place? Is it the night-time refuge of some petty bourgeois who habitually descends into his cellar to do some sawing every night? Is this still life installation a discussion of artistic forerunners, such as Alberto Giacometti's studio drawings or Cézanne's still lives? Or is a stage set for a horror film? Are we therefore likely to encounter his abandoned room in a different media context again?

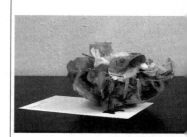

The obfuscation of media manifestations is a thread that can be observed throughout Renggli's work. It uses, as it were, the tools of a naïve phenomenology and a continually fresh and inquisitive look at supposedly secure and established facts. When attempting to map installational situations, any unquestioning identification must therefore remain precarious. In some exceptional cases, these situations have apparently been set up only for the moment of photographic documentation, for instance a split salad bowl ("Salad Lips", 2003). This makes it easier to judge their forms of presentation, as the rotting green salad and the oozing balsam vinegar would otherwise be unreasonable to maintain in any presentation of an installation. However, this unambiguous media status can only be found in a small number of pictorial reproductions. In most cases the artist operates within the grey area of our perception. "Those Who Have Slept Their Way Up" (2005) appears to show an easel in an artist's studio. It is set against a white wall and takes the form of dark wooden slats with spots and splashes of paint: apparently the artist's tool. A second glance, however, reveals that this is not really a painter's tool but a sculptural reconstruction of it. And if we look even more closely, then the simulated medium of the painting that is being created has the characteristics of a picture frame. The medium itself thus becomes a picture which, in turn, becomes an empty installational space that does no more than provide a frame for the wall behind it. And the photo – if it is a photo – demonstrates precisely this mechanism.

Such labyrinthine obfuscations are presented by Renggli with special prominence in his "Helmet from Behind" (2002). The picture – a photograph – represents an installation consisting of a chair, two three-legged stands (probably a music stand and a photographic

also wiederum viele Spuren gelegt. Aber Renggli zeigt in diesem Werk auch deutlich, wie man damit umzugehen hat: mit Perspektivewechseln. Die Handspiegel, «gehalten» von den Handschuhen, reflektieren den zwischen ihnen platzierten Helm, bilden sozusagen ein improvisiertes Mini-Spiegelkabinett, in dessen Fokus sich unter dem Helm ein Phantom befindet, gewissermassen eine Potenzierung des Lacan'schen Phantasmas verkörpernd. Anders gesagt: Der Betrachter sieht das Bild, wie es sich selbst betrachtet. Diese ausgeklügelte, künstlerische Versuchsanordnung handelt natürlich auch von der narzisstischen Spiegelung, von der Unmöglichkeit, sich selbst so zu sehen, wie einen die Welt sieht. Und von der Neugier, die eigene-andere Seite betrachten zu wollen, die durch die doppelte Spiegelung dennoch nur eine abstrakte Realität bleiben kann. «Liebe dein Symptom wie dich selbst», müsste man mit Bezug auf Slavoij Žižek sagen, der damit die Folgen der medialen Spiegelungen auf unsere Subjektwahrnehmung und Subjektkonstruktion meint.

Dass vor diesem Hintergrund die Auseinandersetzung mit der eigenen Berufsgattung in Rengglis Kunst einen gewissen Stellenwert geniesst, wird immer wieder deutlich und vor allem dann virulent, wenn auf die eine oder andere Weise Referenzen an die Arbeit von Künstlerkollegen gemacht bzw. auf die Mechanismen des Kunstbetriebs angespielt wird. Die Frage, welche Rolle der Künstler in der Gesellschaft und im System spielt bzw. welche Wege in der Nach-Postmoderne für einen Künstler noch gangbar sind, stehen im Zentrum von Rengglis durchaus selbstbezogener Recherche. «For What Would You Believe Something You Don't Believe» (2006) verdeutlicht diese Haltung auf exemplarische Weise. Die Installation – sie zeigt einen Besen, der an einem Heizungsradiator lehnt – ist einerseits in ihrer bildhaften Ambiguität zwischen zweidimensionaler Abbildungshaftigkeit und dreidimensionaler Machart charakteristisch für Rengglis Auslotung der medialen Grauzone. Andererseits referiert die Ikonografie des installativen Stilllebens auf eine Reihe allseits bekannter Topoi der Gegenwartskunst: Robert Gobers Nachbau alltäglicher Raumkonstellationen kommt einem in den Sinn; Fischli/Weiss' Diskurs des Gewöhnlichen; Max Bills Vertikalismus von Bild und Raum; Warhols Ready Mades der postindustriellen Konsumgesellschaft. Und wer sich in Zürichs Kunstszene etwas besser auskennt, identifiziert den Heizkörper als architektonisches Versatzstück im Eingangsbereich des Löwenbräu-Areals. Denn auch an diesem Ort der Präsentation und der Kommerzialisierung von Kunst findet die Künstler-Subjekt-Konstruktion statt, hier werden die Mythen erfunden, hier ist der Ort des Selbstinszenierung,

tripod), a motorbike helmet, two gloves, two hand mirrors and some screw clamps. In the background we can seen some brown lounge stools, thus underlining the idea that these might be standard elements of a musical scene. All the items might have been taken from the practice room of a teeny band. Again, there are numerous tell-tale signs. But Renggli also shows very clearly how this work must be looked at: with changing perspectives. The hand mirrors, "held" by the gloves, reflect the helmet placed between them, forming, as it were, an improvised miniature cabinet of mirrors. The mirrors focus on a phantom underneath the helmet, embodying, so to speak, Lacan's phantasm to an extreme degree. In other words, the viewer can see the picture as it would see itself. Obviously, this witty artistic experimental setup is also an instance of narcissistic mirroring, thus illustrating the impossibility of seeing oneself in the same way as one is seen by the world. And it is about the inquisitive desire to view one's own other side, although the double mirroring effect means that it cannot be more than an abstract reality. "Love your Symptom as Yourself", we would have to say, quoting Slavoij Žižek who meant the consequences of mirroring in specific media on our self-perception and self-construction.

Set against this background, a certain place in Renggli's art is also occupied by a discussion of his own specific type of profession. This can be seen again and again. It shows itself particularly virulently whenever he refers in one way or another to the works of other artists or when he alludes to the mechanisms of the art scene. Renggli's quest, which clearly has references to himself, centres upon the question of the artist's role in society and in the system and also the question which paths are possible for an artist in this age of post-post modernism. "For What Would You Believe Something You Don't Believe" (2006) illustrates this attitude very clearly indeed. Showing a broom leaning against a radiator, the installation thrives on an artistic ambiguity between two-dimensional depiction and a three-dimensional style. This makes it a typical representative of Renggli's endeavour to plumb the depths of the grey area of artistic media. On the other hand, the iconography of the installed still life points to a range of universally known topoi in contemporary art: what springs to mind is Robert Gober's reconstruction of everyday

des Self-Engineerings. Und dafür baut Renggli schliesslich seine Kraftmaschinen: chromglänzende Apparate, mit denen die Körper gestählt werden – sofern die amateurhaften Schweissnähte das Gewicht zu tragen im Stande sind und der Benutzer die von Renggli eingebauten schiefen Winkel und Asymmetrien ausbalancieren kann.

room constellations, Fischli/Weiss's discourse on the ordinary, Max Bill's verticality of the picture and space, and Warhol's ready-mades of our post-individual consumer society. And anyone who knows their way round Zurich's art scene will identify the radiator as an architectural component in the entrance area of the Löwenbräu-Areal – a venue where art is presented and commercialised, where the artist's self-construction takes place, where myths are invented and where self-engineering and self-projection occur. And this is of course why Renggli builds his power machines: chromium-clad machines that add a steel-like quality to the objects – provided that their amateur-like welding seams can bear the weight and the user can balance out the crooked angles and asymmetries installed by Renggli.

david renggli

*1974 in Zürich, lebt und arbeitet/lives and works in Zürich

einzelausstellungen/
solo exhibitions

2008	Giò Marconi, Milano
2007	You're Only Once, Twice my Age, **ausstellungsraum25, Zürich**
	Arm Holds Hand, **Alexandre Pollazzon Ltd, London**
	Lieber eine umgebaute Haus als eine umgebaute Mann, **Binz 39, Zürich, mit Steffen Koohn**
	You, Can you Recommend Your Psychiatrist?, **Via Farini, Milano**
2006	Leihgabe ans Nichts, **Kunsthalle Winterthur**
	Van Zoetendaal Collections, Amsterdam
	The Night it Suddenly Became Bright Again, **Flaca, London**
	Sometimes Sunday is on Tuesday, **Chez Valentin, Paris**
2005	Hommage an die Interpretation der Zeit, **La Rada, Locarno**
2004	The Irony of Schicksal, **ausstellungsraum25, Zürich**
2003	Technologie & Eifersucht, **Volkartstiftung Coalmine Fotogalerie, Winterthur**
	Kerzenziehen, **Slauer Baal, Zürich**
2002	Retrospektive David Renggli, **Messagesalon, Zürich**
	An der grossen Frage wird nach wie vor gearbeitet…, **Installation/Performance mit Kerim Seiler, Schauspielhaus, Zürich**
1997–2007	Waldorf, Studio & Performance Band

gruppenausstellungen/
group exhibitions

2008	Shifting Identities, **Kunsthaus Zürich**
2007	Nouvelles acquisitions/Volet 1, **FRAC Nord – Pas de Calais, Dunkerque**
	Les Artistes de la Collection Cahiers d'Artistes, **Serie VI+VII, Fri-Art, Fribourg**
	Bodycheck, **10. Triennale der Kleinplastik, Fellbach/Stuttgart**
	Timer01, **Triennale di Milano**
	Mythos, **Upstairs, Berlin**
	Our Magic Hour, **Arario, Seoul**
2006	Housewarming, **Swiss Institute, New York**
	Aller-Retour 2/Carte blanche à Fischli/Weiss, **Centre Culturel Suisse de Paris**
	The Expanded Eye, **Kunsthaus, Zürich**
2005	Friedhof-Design, **Museum Bellerive, Zürich**
	The Parable Show, **Galerie Grimm/Rosenfeld, München**
	Plakat Hardau, **Kunst und Öffentlichkeit, Stadt Zürich**
2004	Mind over Manner, **Galerie Grimm/Rosenfeld, München**
	Kunstlicht Kongress, **Galerie Walcheturm, Zürich**
	Made in video. Single Channel Projections from Switzerland, **Art Athina 2004, Athens**
2003	It's in our hands, migros museum für gegenwartskunst, Zürich
	Game Over, **Galerie Grimm/Rosenfeld, München**
	Les jeux sont faits, **Adrian Rosenfeld Penthouse 64, Chateau Marmont, Los Angeles**

bibliographie/bibliography

Jörg Becher, «Unheimliche Normalität», in: Die 50 wichtigsten Künstler der Schweiz, Echtzeit Verlag, Basel 2007

Joanne Bernstein, «Double Take», in: **Joanne Bernstein (Ed.), UBS Young Art, Zürich 2007**

Denis Brudna/Anna Gripp, «Fokus Stilleben», in: **Photonews, Februar 2006**

Giovanni Carmine, «Ein sehr schöner Titel», in: **David Renggli. Du kannst mir auch Du sagen, Collections Cahiers d'Artistes 2006, Pro Helvetia/Edizioni Periferia, Luzern 2006**

Milovan Farronato, «From Dusk Till Dawn», in: **Tema Celeste, July 2007**

Martin Herbert, «David Renggli», in: **Time Out, London, 15.6.2007**

Verena Kuni, «An der grossen Frage wird nach wie vor gearbeitet…», in: **Kunst-Bulletin, 12/2006**

Fabiola Naldi, «Tutti in classe allo spazio la rada», in: **Kunst-Bulletin, 9/2005**

Cornelia Providoli, «A Second Look», in: **Joanne Bernstein (Ed.), UBS Young Art, Zürich 2007**

auszeichnungen/awards

2007	Art Grant of the Town of Zürich
	Swiss Art Awards, Basel
2006	UBS Young Art Award
	Art Grant of the Kanton Zürich
2005	Art Grant of the Kanton Zürich

abgebildete werke/
list of reproduced works

1000 und eine Bilder, 2006–2007
(Serie von 1001 Bildern)
Bild gerahmt, verschiedene Techniken, verschiedene Grössen
(Series of 1001 paintings)
Framed picture, various techniques, various dimensions

Nr. 366
Seite/Page 1

Nr. 381
Seite/Page 2

Nr. 89
Seite/Page 3

Nr. 932
Seite/Page 4

Nr. 181
Seite/Page 5

Nr. 733
Seite/Page 6

Nr. 429
Seite/Page 8

Nr. 189
Seite/Page 9

Nr. 227
Seite/Page 10

Nr. 614
Seite/Page 11

Holz macht süchtig, 2007
Gefärbte Wolle, Kunststoff/Dyed wool, plastics
62 × 20 × 16 cm, Seite/Page 17

Truhe mit Spalt, 2004
C-Print, gerahmt/C-Print, framed
60 × 80 cm, Seite/Page 18

Interview with a Wall II, 2007
Fichtenholz, gebeizt/Spruce, wood stain
210 × 300 × 8 cm
(Ausstellungsansicht/Installation view, Helmhaus Zürich)
Seite/Page 19

Die, die sich hochgeschlafen, 2005
Holz, Kunststoff, Farbe/Wood, plastics, paint
250 × 160 × 60 cm, Seite/Page 20

Study for Enlightment, 2007
Holz, Metall, Glas, Lichtinstallation
Wood, metal, glass, electrical light fitting
180 × 20 × 25 cm, Seite/Page 21

The Night it Suddenly Became Bright Again, 2006
Holz, diverse Gegenstände, schwarze Farbe,
Sägespäne, Kappsäge
Wood, various objects, black paint, saw dust, miter saw
400 × 240 × 200 cm
(Ausstellungsansicht/Installation view, Flaca, London)
Seite/Page 22, 23

The Night it Suddenly Became Bright Again, 2007
Holz, diverse Gegenstände, schwarze Farbe,
Sägespäne, Kappsäge
Wood, various objects, black paint, saw dust, miter saw
500 × 260 × 300 cm
(Detail, Swiss Art Awards 07, Basel)
Seite/Page 24

Study for Enlightment (Nr. 5), 2007
Holz, Metall, Glas, Lichtinstallation
Wood, metal, glass, electrical light fitting
67 × 43 × 47 cm, Seite/Page 25

Train from A to B (Hangout I), 2007
Metall, verchromt, Leder, Schaumstoff, Holz
Metal, chrome finish, leather, rubber foam, wood
200 × 100 × 55 cm
(Ausstellungsansicht/Exhibition view, Arm Holds Hand,
Alexandre Pollazzon Ltd, London)
Seite/Page 26

Train from A to B (Hangout II), 2007
Metall, verchromt, Leder, Schaumstoff, Holz
Metal, chrome finish, leather, rubber foam, wood
100 × 70 × 55 cm
(Ausstellungsansicht/Exhibition view, Arm Holds Hand,
Alexandre Pollazzon Ltd, London)
Seite/Page 27

Flat Tire Make Higher, 2006
Holz, Kunststoff, Kette/Wood, plastics, chain
380 × 260 × 110 cm, Seite/Page 28, 29

Study for Enlightment (Nr. 2), 2007
Holz, Metall, Glas, Lichtinstallation
Wood, metal, glass, electrical light fitting
67 × 43 × 47 cm, Seite/Page 30

Study for Enlightment (Nr. 3), 2007
Metall, Glas, Lichtinstallation
Metal, glass, electrical light fitting
67 × 43 × 47 cm, Seite/Page 31

The Night Sculptures I, 2007
Holz, diverse Objekte, schwarze Farbe, Sägespäne
Wood, various objects, black paint, saw dust
170 × 80 × 80 cm, Seite/Page 32

The Night Sculptures II, 2007
Holz, diverse Objekte, schwarze Farbe, Sägespäne
Wood, various objects, black paint, saw dust
160 × 70 × 70 cm, Seite/Page 33

Bagger essen Wand auf (Nr. 4), 2007
Hinterglas-Malerei, Druck, MDF-Kastenrahmen
Reverse glas painting, print, MDF framed vitrine
51,5 × 41,5 × 4 cm, Seite/Page 34

Die, die sich hochgeschlafen, 2005
Holz, Farbe, Kunststoff/Wood, paint, plastics
250 × 160 × 60 cm
(Ausstellungsansicht/Exhibition view, Via Farini, Milano)
Seite/Page 35

Holz macht süchtig, 2007
Gefärbte Wolle, Kunststoff/Dyed wool, plastics
ca. 89 × 62 × 16 cm, Seite/Page 36

Strippen für Piepen (Stripped Bike I), 2007
Metall, verchromt/Metal, chrome finish
320 × 78 × 18 cm, Seite/Page 37

For What Would You Believe Something You Don't Believe, 2006
Holz, Metall, Lackfarbe, Besen/Wood, metal, enamel, broom
220 × 150 × 14 cm
(Ausstellungsansicht/Exhibition view, The Expanded Eye, Kunsthaus Zürich)
Seite/Page 38, 39

Strippen für Piepen (Stripped Bike II), 2007
Metall, verchromt/Metal, chrome finish
63,9 × 78 cm, Seite/Page 40

Im stehen siehts sich höher, 2005
C-Print, gerahmt/C-Print, framed
40 × 50 cm, Seite/Page 41

Train from A to B (Hangout II), 2007
Metall, verchomt, Leder, Schaumstoff, Holz
Metal, chrome finish, leather, rubber foam, wood
100 × 70 × 55 cm
(Ausstellungsansicht/Exhibition view, Arm Holds Hand, Alexandre Pollazzon Ltd, London)
Seite/Page 42

While I Work My Bed Sleeps, 2007
Holz, Farbe, Kissen, Duvet, Stoff/Wood, paint, pillow, duvet, fabric
75 × 200 × 90 cm
(Ausstellungsansicht/Exhibition view, Arm Holds Hand, Alexandre Pollazzon Ltd, London)
Seite/Page 43

Interview with a Wall, 2007
Fichtenholz, gebeizt/Spruce, wood stain
230 × 550 × 14 cm
(Ausstellungsansicht/Exhibition view, Arm Holds Hand, Alexandre Pollazzon Ltd, London)
Seite/Page 44, 45

Study for Enlightment, 2007
Metall, Glas, Lichtinstallation
Metal, glass, electrical light fitting
67 × 43 × 47 cm, Seite/Page 46

Bagger essen Wand auf (No. 10), 2007
Hinterglas-Malerei, Druck, MDF-Kastenrahmen
Reverse glas painting, print, MDF framed vitrine
51,5 × 41,5 × 4 cm, Seite/Page 47

Des Gabels Gabe, 2005
Ahorn, Kette, Farbe, Kunststoff
Maple, chain, paint, plastics
110 × 60 × 20 cm, Seite/Page 48

Strippen für Piepen (Stripped Bike I+II), 2007
(Ausstellungsansicht/Exhibition view, ausstellungsraum25, Zürich)
Seite/Page 49

The Night it Suddenly Became Bright Again, 2007
Holz, div. Gegenstände, schwarze Farbe, Sägespäne, Kappsäge
Wood, various objects, black paint, saw dust, miter saw
250 × 850 × 450 cm
(Ausstellungsansicht/Exhibition view, Your Magic Hour, Arario Gallery, Seoul, Korea)
Seite/Page 50, 51

Sometimes I Wish the World was in Slowmotion, 2007
C-Print, Aluminium, Motor, Steuerung
C-Print, aluminium, motor, controller
122 × 122 × 80 cm

Train from A to B (Hangout III), 2007
Metall, verchomt, Leder, Schaumstoff, Holz
Metal, chrome finish, leather, rubber foam, wood
80 × 140 × 44 cm
(Ausstellungsansicht/Exhibition view, Alexandre Pollazzon Ltd, London)
Seite/Page 52

Sometimes I Wish the World was in Slowmotion (Studies), 2006
C-Print/C-Print
Seite/Page 54, 55, 56, 57, 58, 59

Portrait Nr. 4, 2002
C-Print, gerahmt/C-Print, framed
80 × 100cm, Seite/Page 61

Sometimes Sunday is on Tuesday, 2006
Glas, Alkohol, Holz, Gummi, Früchte, Gemüse und diverse Gegenstände
Glass, spirit, wood, rubber, fruit, vegetables and various objects
84 × 63,5 × 14 cm
(Ausstellungsansicht/Exhibition view, Galerie Chez Valentin, Paris)
Seite/Page 62, 63

You're Always Late, 2007
Links: Between Open and Closed, rechts: Open
Holz, Metall, Glas, Lackfarbe
Left side: Between Open and Closed, right side: Open
Wood, metal, glass, enamel
je/each 110 × 74 × 5 cm
(Ausstellungsansicht/Exhibition view, ausstellungsraum25, Zürich)
Seite/Page 64

Helm von hinten, 2002
C-Print, gerahmt/C-Print, framed
80 × 100 cm, Seite/Page 65

Perspecktiven, 2002
C-Print, gerahmt/C-Print, framed
80 × 100 cm, Seite/Page 66, 67

Einsicht durch Durchschnitt, 2006
C-Print, gerahmt/C-Print, framed
30 × 40 cm, Seite/Page 68, 69

Spiegelung, 2002
C-Print, gerahmt/C-Print, framed
40 × 50 cm, Seite/Page 70, 71

You're Always Late (Between Open and Closed), 2007
Holz, Metall, Glas, Lackfarbe/Wood, metal, glass, enamel
70 × 46 cm, Seite/Page 72

Im Wasser, 2006
C-Print, gerahmt/C-Print, framed
40 × 50 cm, Seite/Page 73

Das grosse Rasenstück, 2005
Gepresste und getrocknete Pflanzenteile auf Papier, Zigaretten
Pressed and dryed plants on paper, cigarettes
60 × 40 cm, Seite/Page 75

Truhe für gestohlene Zeit, 2004
C-Print, gerahmt/C-Print, framed
80 × 100 cm, Seite/Page 76, 77

Jalousienlicht, das sich an der Ecke bricht, 2004
C-Print, gerahmt/C-Print, framed
80 × 100 cm, Seite/Page 78

Durst kommt vor Singen, 2006
C-Print, gerahmt/C-Print, framed
30 × 40 cm, Seite/Page

Kranz unten, 2004
C-Print, gerahmt/C-Print, framed
80 × 100 cm, Seite/Page 80

Ab welchem Alter wirken Selbstgespräche eigentlich komisch, 2005
Styropor, Kunststoff, Lackfarbe/Styrophoam, plastics, enamel
45 × 60 × 21 cm, Seite/Page 81

Hommage an die Interpretation der Zeit, 2005
Polyurethan, Seil, Kunststoff, Wachs, Holz, diverse Gegenstände
Polyurethane, rope, plastics, wax, wood, various objects
Grösse variabel/Dimension variable
(Ausstellungsansicht/Exhibition view, La Rada, Locarno)
Seite/Page 82, 83

Leihgabe ans Nichts, 2006
Holz, Metall/Wood, metal
8 × 200 × 450 cm
(Ausstellungsansicht/Exhibition view, Kunsthalle Winterthur)
Seite/Page 84, 85

Compressed Pub, 2006
Holz, Filz, Glas, Heizkörper, Klebefolie, Zigaretten, Farbe
Wood, felt, glass, radiator, adhesive foil, cigarettes, paint
200 × 180 × 200 cm
(Ausstellungsansicht/Exhibition view, Flaca, London)
Seite/Page 87

If I Could Paint, I Would Paint You a House, 2007
Holz, Klinkersteine, Holzkohlebrand, Mörtel
Wood, clinker brick, charcoal burning, mortar
Grösse variabel/Dimension variable
(Ausstellungsansicht/Exhibition view, ausstellungsraum25, Zürich)
Seite/Page 88

Was befohlen, wird gemacht, 2004
Styropor, Metall, Spachtelmasse, Farbe
Styrofoam, metal, plaster, paint
200 × 100 × 100 cm

Antwort aus der Höhle der Fragen, 2004
Styropor, Spachtelmasse, Farbe
Styrofoam, plaster, paint
100 × 100 × 100 cm, Seite/Page 89

Berg der Beleidigten, 2003
C-Print, gerahmt/C-Print, framed
65 × 80 cm

Lust und Moral, 2006
Keramik, glasiert/Ceramic, glazed
60 × 17 × 10 cm, Seite/Page 90

Des Tumblers Gabe, 2007
C-Print, gerahmt/C-Print, framed
50 × 40 cm, Seite/Page 91

Der Apfel fällt nicht, 2004
Styropor, Kunststoff, Lackfarbe/Styrofoam, plastics, enamel
35 × 50 × 15 cm, Seite/Page 92

While I Work my Bed Sleeps, 2007
Holz, Farbe, Kissen, Duvet, Stoff/Wood, paint, pillow, duvet, fabric
75 × 200 × 90 cm
(Ausstellungsansicht/Exhibition view, Alexandre Pollazzon Ltd, London)
Seite/Page 94, 95

Melancholie von Hinten und von Vorne, 2005
Xerox-Kopien, gerahmt/Xerox copies, framed
60 × 45 cm, Seite/Page 96, 97

Es widerspricht jeglicher mir anerzogenen Logik dass das
n auf das m folgt, 2005
Dachlatten, Plastik, Post-it's/Lath, plastics, Post-it's
160 × 70 × 60 cm
(Ausstellungsansicht/Exhibition view, Helmhaus, Zürich)
Seite/Page 98

Retouchen, 2007
Salatblätter, gepresst, getrocknet/Salad leaves, pressed, dried
30 × 24 cm, Seite/Page 100–107

Der Tag an dem ich das Brot erfand (Swan Straight), 2007
Metall, Federn, Teer/Metal, feathers, tar
90 × 60 × 16 cm, Seite/Page 111

Der Compagnon

Ich gehe also in der Mitte
der Strasse
beleuchtet
die Avantgarde holt den Menschen vor mir ein
der Kosmos ist nicht in Gefahr
der Rest ist bei Rot über eine Ampel gefahren
ebenfalls beleuchtet
begleitet und verfolgt von Idiotie
der Kosmos ist nicht in Gefahr
der Lptnpt ist nicht in Gefahr
der Kosmos ist nicht in Gefahr

So I'm walking in the middle
of the road
illuminated
the avant-garde catches up with the human ahead of me
the cosmos is not in danger
the rest drove past a red traffic light
also illuminated
accompanied and pursued by idiocy
the cosmos is not in danger
the dptnpt is not in danger
the cosmos is not in danger

Clifford Errol Bruckmann

dank / acknowledgments

Diego Vetter, Meta Kenworthy, Franziska Bodmer, Milovan Faronato, Giovanni Carmine, Cornelia Providoli, Mathias Winzen, Rein Wolfs, Bruno Mancia, Pietro Mattioli, FBM, Raul Sanchez, Scipio Schneider, Saoul Kasnizcke, Bert Fiefelstein, Dorothea Strauss, Christoph Doswald, Polly Wintes, Willem van Zoetendaal, Gregor Metzger, Alexandra Blättler, Binz39, Simon Renggli, Kerim Seiler, Noah Stolz, Christian Andersen, Jürg Trösch, Markus Bosshard, Philipp Schenk, Sara Giancane, Steffen Kuhn, Carlotta Giancane.

bei codax publisher erschienen:
rineke dijkstra, beaches (1997)
ISBN 3-9521227-0-X
claudio moser, dedicated to the warmest flugelhorn tone (1998)
ISBN 3-9521227-1-8
teresa hubbard and alexander birchler, scene (1999)
ISBN 3-9521227-2-6
nobuyoshi araki, skyscapes (2000)
ISBN 3-9521227-3-4
smith/stewart, ahead (2001)
ISBN 3-9521227-4-2
shirana shahbazi, goftare nik (2002)
ISBN 3-9521227-5-0
julian opie, portraits (2003)
ISBN 3-9521227-6-9 (hardcover, not for trade)
walter niedermayr, titlis (2004)
ISBN 978-3-7757-1405-1 (buchhandel/trade)
ISBN 3-9521227-8-5 (not for trade)
bjørn melhus, auto center drive (2005)
ISBN 978-3-7757-1566-9 (buchhandel/trade)
ISBN 3-9521227-7-7 (not for trade)
daido moriyama, shinjuku 19XX–20XX (2006)
ISBN 978-3-7757-1729-8 (softcover, buchhandel/trade)
ISBN 3-9521227-9-3 (hardcover, not for trade)
walter pfeiffer, night and day (2007)
ISBN 3-9523070-0-9 (hardcover, not for trade)
ISBN 978-3-7757-1957-5 (softcover, buchhandel/trade)
david renggli, cage writes bird. (2008)
ISBN 3-9523070-1-7 (hardcover, not for trade)
ISBN 978-3-905829-45-7 (softcover, buchhandel/trade)

bildnachweis:
alexandre pollazzon ltd, london
seite/page 26, 27, 42, 43, 44/45, 52, 94/95.

ausstellungsraum25, zürich
seite/page 34, 37, 40, 47, 49, 64, 88, 92/93.

fbm studio, zürich
seite/page 38/39, 98.

galerie chez valentin, paris
seite/page 62/63.

martin stollenwerk, zürich
seite/page 32, 33, 34, 47, 100–107, 111.

via farini, milano
seite/page 35.

arario gallery, seoul
seite/page 50/51.

david renggli is represented by:
ausstellungsraum25
zürich, switzerland

alexandre pollazzon ltd
london, great britain

galerie chez valentin
paris, france

giò marconi
milan, italy

herausgeber/editor: markus bosshard, christoph doswald, dorothea strauss, jürg trösch
redaktion/editing:
christoph doswald, dorothea strauss
grafische gestaltung/graphic design: wbg ag, zürich
autoren/authors: christoph doswald, dorothea strauss
übersetzung ins englische/translation into english:
hugh beyer (doswald),
julia taylor thorson (strauss)
lektorat/copyediting:
evelyn hofer, visiolink ag

werkverzeichnis/list of works:
meta kenworthy

satz und reproduktionen/typesetting and reproductions:
visiolink ag, zürich
druck/printing: printlink ag, zürich
www.linkgroup.ch

schrift/typeface: akzidenz grotesk bq (g.g. lange, berthold)
papier/paper: luxo®artsamt/furioso, 170 g/m², sihl + eika papier ag, zürich, ein produkt von m-real biberist
buchbinderei/binding:
eibert ag, eschenbach

© 2008 codax publisher, zürich
© 2008 für die abgebildeten werke von/for the reproduced works by david renggli

alle rechte der verbreitung, auch durch film und elektronische medien, fotomechanische wiedergabe, auszugsweisen nachdruck oder einspeicherung und rückgewinnung in datenverarbeitungsanlagen aller art, sind vorbehalten bzw. nicht gestattet. alle rechte vorbehalten/all rights reserved.

verlegt von/published by:
codax publisher, zürich
mühlebachstrasse 52
postfach/p.o. box
ch-8032 zürich
schweiz/switzerland
tel. +41 (0)44 268 12 12
fax +41 (0)44 268 12 13
www.codax-publisher.com

im vertrieb bei/distributed by:
jrp|ringier
letzigraben 134
ch-8047 zürich
tel. +41 (0) 43 311 27 50
fax +41 (0) 43 311 27 51
www.jrp-ringier.com
info@jrp-ringier.com

jrp|ringier publications are available internationally at selected bookstores and from the following distribution partners:
switzerland
buch 2000, ava verlagsauslieferung ag, centralweg 16, ch-8910 affoltern am albis, buch2000@ava.ch, www.ava.ch
germany and austria
vice versa vertrieb, immanuelkirchstrasse 12, d-10405 berlin, info@vice-versa-vertrieb.de
www.vice-versa-vertrieb.de
france
les presses du réel,
16 rue quentin, f-21000 dijon, info@lespressesdureel.com, www.lespressesdureel.com
uk and other european countries
cornerhouse publications, 70 oxford street, uk-manchester m1 5nh, publications@cornerhouse.org, www.cornerhouse.org/books
usa, canada, asia, and australia
d.a.p./distributed art publishers, 155 sixth avenue, 2nd floor, usa-new york, ny 10013, dap@dapinc.com, www.artbook.com
for a list of our partner bookshops or for any general questions, please contact jrp|ringier directly at info@jrp-ringier.com, or visit our homepage www.jrp-ringier.com for further information about our program.

ISBN 978-3-905829-45-7

gedruckt in der schweiz/
printed in switzerland

Deutschsprachige Ausgabe unter der Leitung von Dr. Louis Hertig
Übersetzung und Bearbeitung Fritz-Eugen Keller
© 1969 by Sadea/Sansoni, Florenz, fur den Text
© 1969 by S.P.A.D.E.M., Paris, fur die Illustrationen
Alle Rechte der deutschsprachigen Ausgabe bei Kunstkreis Luzern
Printed in Italy